FIRST IMPRESSIONS

FIRST IMPRESSIONS

NINETEENTH-CENTURY AMERICAN MASTER PRINTS

ALICIA G. LONGWELL

PARRISH ART MUSEUM, Southampton, N.Y.
in association with D Giles Limited, London

PARRISH
ART MUSEUM

First Impressions: Nineteenth-Century American Master Prints
Parrish Art Museum
25 Jobs Lane
Southampton, N.Y. 11968
parrishart.org

The catalogue has been made possible by the
generous support of the Henry Luce Foundation.

Research for this project was generously funded through
The Werner and Maren Otto Endowment Fund for the
Study of the Art and Artists of Eastern Long Island.

First published in 2010 by GILES, an imprint of D Giles
Limited, in association with the Parrish Art Museum.

D Giles Limited, London
4 Crescent Stables,
139 Upper Richmond Road,
London, SW15 2TN, UK
www.gilesltd.com

ISBN: 978-0-943526-55-3 (softcover)
ISBN: 978-1-904832-75-1 (hardcover)

Library of Congress Cataloging-in-Publication Data

Parrish Art Museum.
First impressions : nineteenth-century American master
prints / Alicia G. Longwell. –1st ed.
p. cm.
Catalog of a traveling exhibition of the Parrish Art Museum.
Includes bibliographical references.
ISBN 978-1-904832-75-1 (hardcover) –
ISBN 978-0-943526-55-3 (softcover)
1. Etching, American–19th century–Exhibitions. 2. Etching–
New York (State)–Southampton–Exhibitions. 3. Parrish Art
Museum–Exhibitions. I. Longwell, Alicia Grant. II. Title. III.
Title: Nineteenth-century American master prints.
NE2003.7.P37 2010
769.973'0903407474725–dc22
2010000427

For Parrish Art Museum:
Director: Terrie Sultan
Curator: Alicia G. Longwell
Managing Editor: Alicia G. Longwell

For D Giles Limited:
Copy-edited and proof-read by Melissa Larner
Designed by Miscano Design, London
Produced by GILES, an imprint of D Giles Limited, London
Printed and bound in Hong Kong

All measurements are in inches;
Height precedes width.

Front cover illustration:
Henry Farrer (American, born England, 1844–1903)
Moonrise (detail), ca. 1889
Etching, plate: 11 ¾ × 17 ⅞, sheet: 17 ⅜ × 23 ¼

Back cover illustration:
Mary Nimmo Moran (American, born Scotland, 1842–1899)
"'Tween the Gloaming and the Mirk," 1883
Etching and mezzotint, plate: 7 ½ × 11 ¼, sheet: 15 × 19 ¾

CONTENTS

INTRODUCTION AND ACKNOWLEDGMENTS

This book, the third in a series of publications exploring significant aspects of the Parrish Art Museum's permanent collection, focuses on the American Painter-Etcher movement of the 1880s, a fascinating although short-lived period in the graphic arts in the United States. These etchings complement the Parrish's exceptionally strong examples of turn-of-the-century American painting, underscoring the Museum's dedication to the creative legacy of the art and artists of the region, and the reverberation of these influences throughout the world.

It is through the generosity of Rebecca Bolling Littlejohn, a Southampton resident and art collector, who in 1952 became president of the Museum's Board of Trustees, that the Parrish Art Museum established a collection of American prints. Her revelatory gift of some 300 masterworks of American paintings forms the core of the Parrish holdings today. Mrs. Littlejohn had the foresight to recognize the importance of artists who lived and worked on Long Island's East End and her bequest of some forty prints by the Moran family further illustrated this allegiance. The artists Thomas and Mary Nimmo Moran began coming to East Hampton in 1878, a date that coincided with the beginnings of the American Painter-Etcher movement, which was brought about by a fascination with the etching medium that caught the imagination of a broad spectrum of painters, illustrators, and publishers. These artists had a two-fold aesthetic agenda: to reinvigorate the practice of etching, and to challenge the public perception of engraving as simply a reproductive medium. The Painter-Etchers sought to imbue the tightly rigid line and high finish of engraving with the same sense of freedom and spontaneity that was the guiding principle of their painting. The Morans, especially, found the etcher's needle an ideal tool for recording the East End's atmospheric landscapes and here they produced some of the etching revival's most beautiful images.

In 1976, the Museum's print collection expanded dramatically with Robert Dunnigan's gift of an unusually rich cache of prints by the most important artists associated with the American Painter-Etcher movement. Most of the impressions were inscribed in pencil on the sheet "Selected for myself, Henry E. F. Voigt," or "To Mr. Henry E. F. Voigt with the compliments of the Etcher." Research led to the identification of Voigt as a master printer and proprietor of an atelier in lower Manhattan who worked during the height of the etching revival in the 1880s on leading publications such as S. R. Koehler's *American Art Review* (1879–1881), and later with prominent independent publishers like Frederick Keppel and Christian Klackner. A group of over 500 prints was purchased by Dunnigan directly from Voigt's descendents and arrived virtually intact on the Museum's doorstep. Many of the prints are *bon à tirer*, that is, the first impression that is fully acceptable to the artist and the printer. This "master" print serves as the standard of quality against

which each subsequent impression is compared. By longstanding tradition, the print is the property of the collaborating printer. The workmanship and quality of these etchings brings us to the critical moment of innovation and artistic accomplishment as the sheet is pulled from the press, revealing an extraordinary moment of collaboration between artist and master printer.

The ranks of the "painter-etchers" (as the artists called themselves to distinguish their work from that of commercial graphic artists) included, in addition to the Morans, leading American artists of the day, such as William Merritt Chase, Henry Farrer, Stephen Parrish, James D. and George H. Smillie, John Henry Twachtman, and Thomas Waterman Wood. This unique collection speaks to the creativity of artists who, confronted with the rise of industrialization, stressed the importance of the handmade gesture as key to any aesthetic impulse. It is noteworthy that many of the most technically innovative prints included were created by Moran and his wife, the artist Mary Nimmo Moran, who established a home and studio in East Hampton in the 1880s, highlighting once again the significance of the Parrish's historical place and the celebration of the unique creative character of Long Island's East End.

Many individuals have contributed to this important volume. Alicia Longwell, Lewis B. and Dorothy Cullman Chief Curator, Art and Education, has given us an essay that illuminates the diverse artistic and cultural milieu that fostered the etching revival in America. Maureen O'Brien, currently curator of Painting and Sculpture at the Museum of Art, Rhode Island School of Design, began the scholarly research on this collection during her tenure at the Parrish and her seminal contribution is gratefully acknowledged here. Registrar Chris McNamara and Curatorial Assistant Sam Bridger Carroll have adeptly and with great enthusiasm overseen the myriad details pertaining to photography, captions and overall management of the manuscript preparation. At D Giles Limited, London, we are grateful for Miscano Design's elegant creative approach; Melissa Larner for precise copyediting; Allison Giles and Sarah McLaughlin for administration, and of course to Dan Giles himself for guiding us through every stage of the project.

We are deeply indebted to the Henry Luce Foundation for providing the Parrish with the critical support to publish this volume and to delve deeply into the strengths of the collection, provide original scholarship, and illuminate the important contributions the collection makes to the understanding and appreciation of American art. We are confident that this publication, the third in a series dedicated to illuminating the richness of the Parrish collection, reflects the quality of our holdings and the tradition of scholarship that has marked the Parrish from its beginnings.

Terrie Sultan
Director

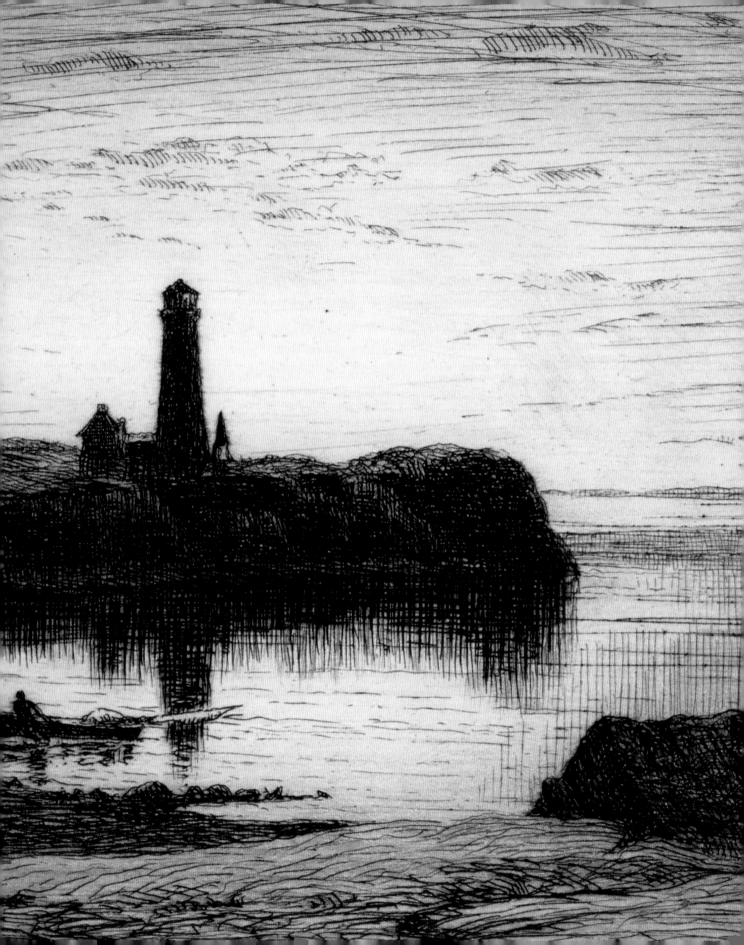

FIRST IMPRESSIONS

The American Painter-Etcher movement was the result of a remarkable confluence of transformative ideas in technology, politics, economics, and aesthetics during the last decades of the nineteenth century. The 1870s furnished the climate for the inception of the trend, and the 1880s witnessed its flourishing, only to be followed by a precipitate decline in the 1890s. The etchings in the Parrish's Dunnigan Collection, from which this catalogue is largely assembled, were created for the most part in the 1880s and thus offer a highly focused account of the movement.

The term "painter-etcher" was embraced as a way to emphasize the fact that the etchings produced by these painters were original works of art. It is perhaps difficult today to grasp the concept of multiples being viewed as "original." At the time, they were considered "freehand etchings," and it was understood that the artist himself pulled the print at his own press or in a fellow artist's studio, or that he supervised the process. The term "painter-etcher" was also used to distinguish the creator from the reproductive etcher, who only copied works by other artists. The term evidently required some explanation for the layman. An 1884 pamphlet aimed at the nascent print collector put it this way: "Painter etchings have the value of original works. They are esteemed as showing the methods and spirit of the artist, just as a sketch by him would. Those who own an etching by [a painter-etcher] really own an original drawing by him. The only difference is that it is drawn on metal instead of paper and can be mechanically reproduced."[1]

Although the last quarter of the nineteenth century represented the high point of the "painterly" interest in etching in the United States, it would be misleading to characterize the earlier part of the century as unaware of the artistic capability of the print medium. There was a strong market for engravings, and many painters, like the marine artist Thomas Birch (American, b. England, 1779-1851) of Philadelphia, made engravings after their own paintings. Chromolithography was in wide use by the 1820s, and firms such as Currier & Ives (begun as Stoddard and Currier in the 1830s) produced prints popular for their association with historic and literary figures. At the request of the Boston-based publisher Louis Prang (who had by the 1870s created a thriving market for chromolithographic prints), Thomas Moran selected fifteen watercolors from his 1871 trip to Yellowstone with Ferdinand V. Hayden's U.S. Geological Survey to be reproduced

1 Charles Klackner, *Proof and Prints: Engravings and Etchings, How They Are Made, Their Grades, Qualities and Values and How to Select Them* (New York: C. Klackner, 1884), 16.

Henry Farrer: *Sunset Coast of Maine* (large detail), 1878

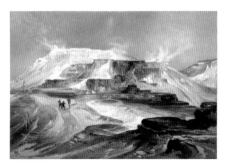

Figure 1
Thomas Moran (American, b. England, 1837–1926)
Hot Springs of Gardiner's River, Yellowstone, 1876
Chromolithograph, 9 ½ × 14 inches
Courtesy Arader Galleries, Philadelphia

Figure 2
Mrs. President Lincoln,
from a photograph by
[Mathew] Brady, ca. 1864
Engraving, plate: 12 ½ × 9 inches;
sheet: 13 ⅛ × 9 ½ inches
Steel-plate engraving by
Capewell and Kimmel
for *Frank Leslie's Monthly*
Parrish Art Museum,
Southampton, New York,
Dunnigan Collection, 1976.1.441

as chromolithographs in a deluxe portfolio, accompanied by Hayden's text (figure 1). Although it was expected to appeal to art lovers, scientists, collectors, and anyone curious about the West, the portfolio was neither a critical nor a financial success; the chromolithograph was not held in high regard in art circles, disdained for its appeal to ladies' home-decoration schemes.[2]

UNACCUSTOMED EYES: THE AESTHETIC EDUCATION OF AMERICA

Post-Civil War America was a culture awash in images; the public had become accustomed to looking at reproductions in the many periodicals of the era, among which were *Frank Leslie's Illustrated Newspaper*, a weekly founded in 1852, and *Harper's Weekly*, which began publishing in 1857. Coverage of the war had brought reporting to a heightened level and the public consumed these images voraciously. Winslow Homer (1836–1910) was first hired by *Harper's* to sketch reproductions of Mathew Brady's photographs of the war; he subsequently made his own drawings. By the end of hostilities, news sources including *The Atlantic Monthly* and *Scribner's* found themselves in constant competition for newsworthy features and accompanying illustrations. Before the 1880s, the usual method for illustration in books and periodicals was the transfer of an artist's sketch from nature (or from a photograph) to a wood block, which could then be cut by an engraver (figure 2).

2 Joni L. Kinsey, *Thomas Moran's West:
 Chromolithography, High Art, and Popular
 Taste* (Lawrence: University Press of
 Kansas, 2006), 97.

By 1855, a method had been invented by which a photograph could be printed directly on a wood block, thereby removing the artist from the technical process of transfer.[3]

The postwar years brought hope for the healing of the nation, a concentration on progress, and growing economic prosperity. The 1876 centennial of the nation's founding provided a moment not only to reflect on history but also to look to the future. The Centennial Exhibition, officially known as the International Exhibition of Arts, Manufactures and Products of the Soil and Mine, and patterned on the great industrial fairs in Britain and Europe, was held on a 285-acre tract of land in Philadelphia's Fairmount Park and featured more than 250 individual pavilions. The fair boasted nearly nine million visitors (some twenty percent of the entire national population) and celebrated a vision for the future. On prominent display were the decorative arts—a category that included the fine and graphic arts—that were collectively, and with no aspersions, referred to as "bric-a-brac." It was not difficult to pinpoint the reason for the mania that ensued. "Then it was," observed a leading New York antiques dealer in assessing the impact of the fair, "that our fellow-citizens warmed up at the idea of collecting ancient pieces of furniture, old china, old plate, curious relics of all sorts, as well as masterpieces from artists of present and past ages."[4] The trend brought with it a new regard for the print; more than two hundred etchings were exhibited.

This bric-a-brac mania, fueled by a burgeoning urban-dwelling middle class in the 1870s, was informed by the British architect and designer Charles Eastlake's *Hints on Household Taste in Furniture, Upholstery and Other Details* (1868). The handbook offered detailed instructions on all aspects of home decoration, including an extensive chapter on "wall furniture" with directions on how to frame and hang pictures. The advice ran from the practical ("Never hang glazed drawings opposite a mirror"; "A picture rail is preferable to nails") to the aesthetic (Eastlake found gilt out of place for framing engravings and advised plain oak, preferring incised ornament to relief).[5] Further, he pointed out, "the best woodcuts of the present day are perhaps the most desirable examples of modern art which can be possessed at a trifling cost. Chromo-lithographs are of course much more attractive to the public and are popularly supposed to be a cheap and easy method of encouraging pictorial taste; but with a few rare exceptions, they do more harm than good in this respect."[6] George Henry Yewell's etching of a parlor gives a good idea of popular style in interior decoration in the 1880s (figure 3).[7]

3 The invention of the photographic halftone process in the 1880s made possible the direct use of photography in newspapers and magazines. See Elizabeth Lindquist-Cock, *The Influence of Photography on American Landscape Painting 1839–1880* (New York: Garland, 1977), 126.

4 As quoted in Christopher P. Monkhouse, "Bric-a-Brac at the Pedestal Fund Art Loan Exhibition," in Maureen C. O'Brien, *In Support of Liberty: European Paintings at the Pedestal Fund Art Loan Exhibition* (Southampton, New York: The Parrish Art Museum, 1986), 87.

5 Charles L. Eastlake, *Hints on Household Taste in Furniture, Upholstery and Other Details* (Boston: R. J. Osgood and Company, 1970), 202.

6 Ibid.

7 Yewell was a neighbor of the Drexel Cottage, near Saratoga Springs, New York, where the ailing Ulysses Grant spent the last weeks of his life. Yewell had made a painting of the cottage; this etching was created as a memorial to the late president.

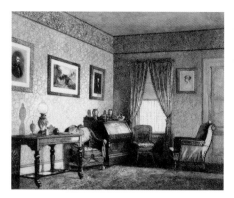

Figure 3
George Henry Yewell (American, 1830–1923)
Room in which General Grant Died
(Drexel Cottage, Mt. McGregor, New York), 1887
Etching, plate: 13 × 15 ¹⁵⁄₁₆; sheet: 19 ⅜ × 25 ⁵⁄₁₆ inches
Parrish Art Museum, Southampton, New York,
Dunnigan Collection, 1976.1.336

An increasingly sophisticated segment of the population discovered the decorative arts at the Centennial Exhibition, and a growing number of artists came to see works on paper, and etchings in particular, as artistic endeavors worthy of pursuit; there was, then, a growing aesthetic awareness on the part of producer and consumer alike. In an article on American etchers for *The Century Illustrated Monthly Magazine*, the critic Mariana Griswold van Rensselaer made a direct correlation between the exhibition and increased attention paid to etching, confirmed by the founding the next year of the New York Etching Club: "The year which followed that of the Centennial Exhibition, when so many unaccustomed eyes had been led to look with interest at things of art, may almost be called an epoch in the history of American development. . .It was the year which saw the birth of the 'New York Etching Club,' an association formed by a few earnest students of the art to incite activity by brotherly reunions and to spread its result by annual exhibitions."[8]

BROTHERLY REUNIONS: THE NEW YORK ETCHING CLUB

The artist James David Smillie had worked assiduously to organize an etchers' association, patterned on similar groups in France and Great Britain, and it was with much anticipation that the first meeting of the New York Etching Club was called to order in Smillie's studio on November 12, 1877.[9] His account, in addition to providing insight into the look, feel, and smell of the etcher's domain and the camaraderie of the club, gives a lucid description of the etching process:

8 M[ariana] G[riswold] van Rensselaer, "American Etchers," *The Century* 25, no. 4 (February 1883), 488.

9 Smillie's studio was in an artists' studio building at the southeast corner of 25ᵗʰ Street and Park Avenue South. See Stephen A. Fredericks, *The New York Etching Club Minutes* (Houston: Rice University Press, 2009), 3.

Those twenty interested artists formed an impatient circle and hurried through the forms of organization, anxious for the commencement of the real work of the evening. Copper plates were displayed; grounds were laid (that is, delicate coatings of resinous wax were spread upon the plates); etchings were made (that is, designs scratched with fine points or needles through such grounds upon the copper); trays of mordant bubbled (that is, the acid corroded the metal exposed by the scratched lines, the surface elsewhere being protected from such action by the wax ground), to the discomfort of noses, the eager wearers of which were crowding and craning to see the work in progress.

The process being completed, in cleansing the wax and grounds and varnish from the plates the fumes of turpentine succeeded those of acid. Then an elegant brother who had dined out early in the evening, laid aside his broadcloth, rolled up the spotless linen of his sleeves, and became for the time an enthusiastic printer. The smear of thick, pasty ink was deftly rubbed into the lines just corroded, and as deftly cleaned from the polished surface; the damped sheet of thin, silky Japan paper was spread upon the gently warmed plate; the heavy steel roller of the printing press, with its triple facing of thick, soft blanket, was slowly rolled over it, and in another moment, finding scant room, the first-born of the New York Etching Club was being tenderly passed from hand to hand.[10]

What precisely was this group of American artists intent on achieving as they gathered in a studio "with a great sky-light. . .filled with dusky gloom. . .easels loom[ing] up bearing vaguely defined work in progress; screens and rugs, bric-a-brac, all the aesthetic properties that we may believe to be the correct furniture of such a place"[11] (figure 4)? They were certainly aware of the revival of the etching technique in France during the 1850s. The Barbizon artists, so called for their relocation from Paris to the picturesque village of Barbizon bordering the Forest of Fontainebleau, created a radically new, closely observed and atmospheric style of landscape painting, perfectly suited to capturing intimate views of rural

10 From the catalogue for the exhibition
 of the New York Etching Club at the
 National Academy of Design (1882),
 as quoted in Fredericks, *The New York
 Etching Club Minutes*, xv.

11 Ibid., xv.

13

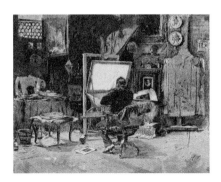
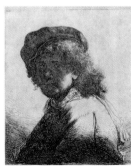

Figure 4
J. H. E. Whitney: *Untitled (after Robert Blum The Modern Etcher, 1882)*, Wood engraving, plate: 3 ¹⁵⁄₁₆ × 5 ¹⁄₁₆ inches; sheet: 5 ⅜ × 7 ¼ inches Parrish Art Museum, Southampton, New York, Gift of Jackson Chase Storm, 1982.11.31

Figure 5
Rembrandt van Rijn (Dutch, 1606–1669)
Rembrandt in a Cap and Scarf with the Face Dark: Bust, 1633 [printed later]
Etching, plate: 5 ¼ × 4 ⅛ inches; sheet: 12 ⅛ × 10 ⅛ inches
Parrish Art Museum, Southampton,
New York, Littlejohn Collection, 1961.3.234

France, and modeled on the landscapes of the seventeenth-century Dutch masters Rembrandt van Rijn, Meindert Hobbema, and Aelbert Cuyp. It was in fact esteem for Rembrandt that led one of the Barbizon artists, Charles Jacque (1813-1894), to attempt an etching after that master, experimenting with what was an almost forgotten technique[12] (figure 5). Jacque was so intrigued by the process that he abandoned painting to pursue etching exclusively.

An admiration for the etchings of Rembrandt, and for the suggestive, sketchy quality of his works, inspired artists in England as well, and by the 1850s an etching revival had gained currency there. Artists were motivated also by the extraordinary work being produced in London by the American expatriate James Abbott McNeill Whistler. And it was Whistler's dynamic engagement with the print medium that sparked the interest of many American artists (figure 6).

"A SORT OF ETCHING CRAZE"

One such American artist was Stephen Parrish. As a young man destined to enter the family coal business, his trip to Europe in the summer of 1867 was a revelation. "I never knew," Parrish wrote in his diary, "that the art of painting was such a vast and splendid profession."[13] Although he later became the proprietor of a stationery store in his native Philadelphia, by 1877 he had sold that business and resolved to pursue a career in painting, a decision not without risks for a thirty-one-year old with a wife and young son.[14]

12 Katharine A. Lochnan, *The Etchings of James McNeill Whistler* (New Haven and London: Yale University Press, 1984), 38.

13 As quoted in Maureen C. O'Brien and Patricia C. F. Mandel, *The American Painter-Etcher Movement* (Southampton, New York. 1984), 41.

14 His son Frederick Maxfield Parrish (1870–1966) was known as the artist Maxfield Parrish. They were cousins of Parrish Art Museum founder Samuel Longstreth Parrish (1849–1932).

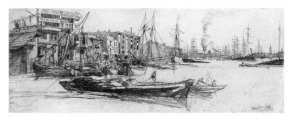

Figure 6
James Abbott McNeill Whislter
(American, 1843–1903)
Thames Warehouse, Hobbs Wharf, 1859
Etching, plate: 3 ⅛ × 8; sheet: 9 × 12 ⅝ inches
Parrish Art Museum, Southampton, New York,
Littlejohn Collection, 1961.3.134

In 1878, Parrish read *Etching & Etchers* (1868) by the English art critic and theorist Philip Gilbert Hamerton (1834-1894). So practical was the volume that it had come to be known as the handbook of the English etching revival.[15] The volume was enormously popular in the United States for both its conversational tone and its useful advice. (An appendix, "Practical Notes," includes instructions for building one's own press.) Under the rubric "Frankness," Hamerton assesses the artistic temperment required of an etcher—a description that perhaps won Parrish over to the pursuit:

> Etching is eminently a straightforward art. . .People do not like plain
> lines that tell rude truths. They prefer fancy arrangements. No good
> etcher will condescend to fancy arrangements. The delightfulness
> of etching, to us who care for it, is especially this frankness. No art
> is so entirely honest; painting and engraving have almost always
> some questionable [degree] of attractiveness, some prettiness or
> polish to suit widespread but lamentable tastes. The etchers, with few
> exceptions, have not attempted to make themselves agreeable in this
> way. . .Of all artists they are the most simple and direct.[16]

Parrish's next step was to apprentice with an established practitioner. In Philadelphia, one needed to look no farther than the studio of Peter Moran, who had distinguished himself as a professional printmaker. Parrish made note of his first session: "Took first lesson from P. Moran. Nov. 24th 1879."[17] Moran, of the renowned Philadelphia family that included his older brothers Edward (1829-1901) and Thomas, was by the late 1870s concentrating exclusively on etching. A work from 1879, his etching after *Landscape and Cattle* by the French artist Emile van Marcke (1827-1890), a painting in the collection

15 The book included a chapter on the etchings of Whistler.

16 Philip Gilbert Hamerton, *Etching & Etchers* (Boston: Roberts Brothers, 1876; originally published in London, 1868), 61.

17 Thomas Bruhn, *American Etchings, the 1880s*, exhibition catalogue (Storrs, Connecticut: The William Benton Storrs Museum of Art, 1985), 112.

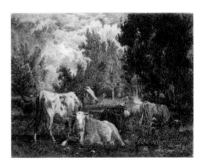

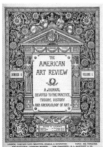

Figure 7

Peter Moran (American, b. England, 1841–1914)
Landscape and Cattle (after Emile van Marcke), ca. 1879
Etching, plate: 6 ¹⁵⁄₁₆ × 8 ¹³⁄₁₆ inches;
sheet: 9 ⅜ × 12 ⁵⁄₁₆ inches
Parrish Art Museum, Southampton, New York,
Dunnigan Collection, 1976.1.255

Figure 8

Cover of *American Art Review*, Volume 1, Number 1, November 1879

of Henry C. Gibson, Esq., of Philadelphia, while not an autograph work, shows Moran's technical mastery of the medium (figure 7).

Etching was the perfect artistic match for Parrish, and by 1881 he was at the forefront of the movement, just when interest in etchings was exploding (plate 54). To a print editor he wrote: "I am just now, & have been for a couple of months in a sort of Etching craze, but they all run large. . .Some of them require goodly space. So goodly that I'm having a bath made—don't tell anybody! 27 × 45 [inches]."[18] Parrish joked that the bath would surely be big enough "to drown myself in case the plates I contemplate don't turn out well"[19]—a hint at the competition that characterized the etching world. Whistler had in fact inveighed from across the ocean against the gigantism of some American printers and their plates, calling the huge coppers "an offense" and their "undertaking. . .a triumph of unthinking earnestness and uncontrolled energy—endowments of the 'duffer.'"[20]

AMERICAN ART REVIEW

The remarkable efflorescence of the Painter-Etcher movement in America might not have been achieved without the enthusiasm and energy of a supporter like P. G. Hamerton in England, who declared that "a treatise on etching is necessarily a treatise on the mental powers of great men."[21] American etchers found that advocate in Sylvester Rosa Koehler (1833-1904), the first curator of prints at the Museum of Fine Arts, Boston. He was the editor and founder of the important *American Art Review* (1879-1881), a journal "Devoted to the Practice, Theory, History and Archaeology of Art" (figure 8). The first issue, in November 1879, opened with an essay by Koehler on the work of American etchers that included a history of the art, and

18 Letter from Stephen Parrish to S. R. Koehler, May 20, 1881, as quoted in O'Brien and Mandel, *The American Painter-Etcher Movement*, 44.

19 Ibid.

20 Ibid., 8.

21 Hamerton, *Etching & Etchers*, xviii.

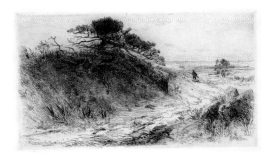

Figure 9
R. Swain Gifford (American, 1840–1905)
The Path to the Shore, 1879
Etching, plate: 4 ⅜ × 7 ⅞ inches;
sheet: 9 ⁵⁄₁₆ × 12 ⁵⁄₁₆ inches
Parrish Art Museum, Southampton,
New York, Dunnigan Collection, 1976.1.251

the affirmation that America's etchers, though not as well known as the French and English, were equally proficient. Further, he intended to provide prima facie evidence in each issue by offering original etchings.[22] Without Koehler's support and acknowledgment, the etching revival in the United States would likely never have achieved the prominence that it did.

One of Koehler's first challenges in realizing a publication of this quality was to find a commercial printer who could produce the original etchings for each issue. He was aware of the skills necessary in a professional printer to render "the softness of the rag wipe, the production of a tint and the more brilliant effects of *retroussage*."[23] His choice was Henry E. F. Voigt, of the New York firm Kimmel & Voigt, and Voigt was apparently more than eager to take on this unprecedented challenge. His initial correspondence with Koehler in Boston was in English ("We think to be able to give you entire satisfaction in this branch of printing and are respectfully soliciting a trial order to be able to proof [*sic*] our success.")[24] Voigt's calling card (figure 10) displays considerable Old World charm, with a scene that looks more like the banks of the Rhine than the shores of the Hudson. In the subsequent voluminous correspondence between the two men (they wrote as frequently as several times a week during the publication of *American Art Review*), Voigt's letters were addressed to the esteemed Herr Koehler and handwritten in "deferential German."[25] Evident throughout the letters is the immense trust that Koehler placed in Voigt, and how earnestly Voigt strove to measure up to that trust.

Among the many artists commissioned during the two years of publication were Mary Nimmo, Thomas and Peter Moran, R. Swain Gifford, Samuel Colman, Henry Farrer, and Stephen James Ferris. The plates were purchased outright from the artists,

22 There were three original etchings in the first issue, including R. Swain Gifford, *The Path to the Shore* (1879; figure 9).

23 Sylvester Rosa Koehler Papers, Archives of American Art, Smithsonian Institution, as quoted in O'Brien and Mandel, *The American Painter-Etcher Movement*, 10. *Retroussage*, from the French, literally means "dragging up," and refers to the technique of gently pulling a cloth over an inked copper plate to draw out some of the ink from the incised line and spread it over the edges to achieve a softened effect.

24 O'Brien, 10.

25 Ibid. Koehler was born in Leipzig in 1837; Voigt was most likely a native of Germany.

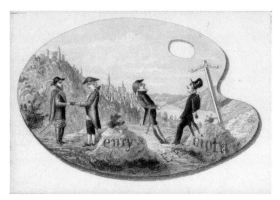

Figure 10
Master printer Henry E. F. Voigt's calling card
2 ½ × 4 inches
Parrish Art Museum Archives, Southampton,
New York, Gift of Roger F. Kipp

who were paid between $50 and $100 and who could retain fifteen signed proofs.[26] The editions were envisioned as 3,000 to 5,000 per month, but this number, it seems, was never attained; there were some 1,500 subscribers. The publisher, Estes & Lauriat of Boston, was forced to abandon the project in September 1881, because of the lavish production costs. Though it was published for little more than two years, the journal's impact was large. The finely printed original etchings in *American Art Review* were benchmarks for the printing of etchings in America, and they established the critical role of the printer in the process. Many of the etchings in the Parrish collection that came from Voigt are signed and dedicated to the printer. On some, Voigt has noted "Selected for Myself." These are the prints that are *bon à tirer*, the first impression fully acceptable to both the artist and the printer.

After the demise of *American Art Review*, Voigt, his firm's reputation established, continued as the master printer sought out by artists committed to their work. The relationship of etcher and printer was complex. For example, Stephen Parrish contracted with Voigt to print ten small plates for a limited-edition illustrated catalogue of his own etchings. On a proof sheet (now in the museum's Dunnigan Collection), Parrish, in Philadelphia, has handwritten advice to his printer in New York City; the subtleties of his instructions suggest that the two have great rapport and further evince the artist's confidence in Voigt's sensitivity and skills. For *Annisquam (No. 2)*, Parrish noted: "Keep an even tint in the sky with very little, or no light in it, touch out the *white house*. The ground will then do as it is." (figure 11)

26 Ibid., 12.

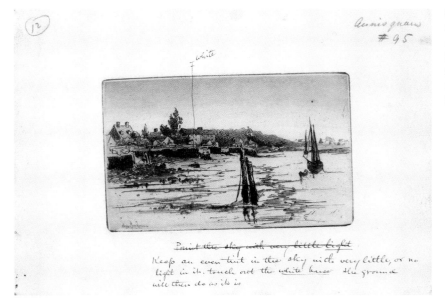

Figure 11

Stephen Parrish (American, 1846–1938)
Annisquam (No. 2), 1884
Etching, plate: 3 ¼ × 5 ⅜ inches;
sheet: 6 ¼ × 9 ⅛ inches
Parrish Art Museum, Southampton,
New York, Dunnigan Collection, 1976.1.17

THE 1880S: THE HIGHPOINT

American Art Review had changed the perception of the "painter-etcher" in America and had confirmed the work of etchers as worthy of contemplation and acquisition. The critic J. R. W. Hitchcock observed that "needle, ground, plate, and mordant are terms used as glibly in our current vocabulary as [are] references to brush, mahl stick, palette, and canvas."[27]

A variety of subjects appeared among American painter-etchers; there were figure studies, such as William Henry Lippincott's *Stolen Moments* (1888; plate 27); genre works like Thomas Waterman Wood's *Fresh Eggs* (1882; plate 71) and Thomas Hovenden's *Untitled (Man Shaving)* (1886; plate 18); and marine themes like that of Henry Farrer's *Sunset Coast of Maine* (1878; plate 7). Most, however, were landscapes. Some of these contained narrative content, such as Augustus van Cleef's poignant *The Tomb of a Modern Leander, Fisher's Island* (1882; plate 69), while others conspicuously featured animals, like J. A. S. Monks's noble ram in *The Patriarch* (ca. 1885; plate 32) and Peter Moran's stately cattle in *Untitled (Cows in Field)* (ca. 1886; plate 41).

27 James Ripley Wellman Hitchcock,
 *Etching in America, with Lists of American
 Etchers and Notable Collections of Prints*
 (New York: White, Stokes & Allen,
 1886), 3.

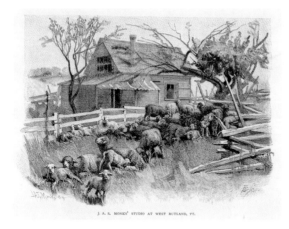

Figure 12
J. A. S. Monks's Studio at Rutland, Vermont,
as reproduced in Lizzie W. Champney,
"The Summer Haunts of American Artists,"
The Century Illustrated Monthly Magazine,
Volume XXX, Number 6,
October 1885, page 857

J. A. S. MONKS' STUDIO AT WEST RUTLAND, VT.

But most are pure landscapes, often depicting sites near the artists' summer studios. The ease and accessibility of railroad travel made it possible to spend the summers working in the countryside within reach of major cities. Monks's studio in West Rutland, Vermont, looked out onto a corral of his beloved sheep (figure 12); R. Swain Gifford stayed near the coastline in New Bedford, Massachusetts. Thomas Moran and Mary Nimmo Moran moved permanently to Long Island's South Fork in 1882. Nimmo Moran was distinguished for etching *en plein air* (in the open air), taking a large copper plate and setting up at picturesque sites in and around the village of East Hampton, as in *"Where Through the Willows Creaking Loud, is Heard the Busy Mill"* (1886; plate 39).

Stephen Parrish and Charles Platt sketched during the summer and etched the plates over the winter in their studios. Not surprisingly, many of the works produced in this period are summer scenes, their subjects ideally suited to the expressiveness of etching. In these gently pastoral vistas, the seasons are often a metaphor for the stages of life; summer, youth, and its attendant pleasures are inseparably linked. Etchings are also exquisitely capable, in their tonal subtleties, of expressing atmosphere and mood, as in Farrer's *Moonrise* (ca. 1889; plate 9) and Nimmo Moran's *Solitude* (1880; plate 33), as well as evanescent times of day and vagaries of weather, as in her *"'Tween the Gloaming and the Mirk"* (1883; plate 36).

These plates were often embellished with "remarques," a small drawing in the margin of the print that the artist would make to test the plate, his needles, or the

strength of the acid bath before working on the central image. Remarques were generally burnished out before the official print run began. The reason why so many of the prints in the collection from Voigt still bear the remarque is that they are the first impressions ("Selected for Myself") before the official prints were run off. Those with remarques became highly desired by collectors because they were more rare. Several splendid examples can be seen in works by Benjamin Lander (plate 25); Nimmo Moran (plate 39); Peter Moran (plate 42); and Parrish's tour de force *Gale at Fécamp (Normandie)* (plate 57).

THE FATE OF ETCHING

By May 1894, J. R. W. Hitchcock, author of the influential *Etching in America* (1886) and a chronicler of the Painter-Etcher movement, was perhaps too quick to sound the death knell in an article that appeared in the New York *Sun*: "The Fate of Etching: Decay of a Fine Art Through Commercial Greed." In a goose-that-laid-the-golden-egg analogy, Hitchcock placed the blame with rapacious publishers and printers who had flooded the market. "An excess of zeal on the part of the publishers led them to the folly of killing their faithful goose in an effort to get all the money there was in circulation. . .Nowadays a man will print 250 impressions in a day, with about as much feeling for expression and tone as a modern. . .press bestows upon newspapers turned out at the rate of nearly 50,000 an hour."[28] It was the practice of steel-plating the copper plate, widely in use by the 1890s, that made the printing of large editions possible—a measure that Voigt had eventually convinced Koehler was necessary to assure quality throughout the printing of an edition for *American Art Review*. The steel plating had the unexpected consequence of increasing exponentially the number of prints that could be pulled from a single plate.

The New York Etching Club meeting on December 8, 1893, was the last one held, although the group did mount an exhibition the next year. In an article titled "Etching and Painter Etching," written for *The Quarterly Illustrator* and published in 1894, James D. Smillie optimistically predicted a bright future for etching in America. Some sixteen years had passed since the first meeting of the Club in his studio. The market had become saturated and the movement had lost momentum. The etching revival in America, though brief, was an unparalled moment of artistic practice and aesthetic endeavor whose "primal gospel," as the critic Alfred Trumble phrased it, was that "an etching should express an idea by the perfection of its suggestiveness and at the least expenditure of labor."[29]

28 J. R. W. Hitchcock, "The Fate of Etching: Decay of a Fine Art Through Commercial Greed," New York *Sun*, May 6, 1894. I am indebted to Stephen A. Fredericks for directing me to this article.

29 Alfred Trumble, "Etching in America— The False Gospel and the True," *The Art Review*, II:1,2,3, Sept.–Nov. 1887, 26.

PLATES

ALBION H. BICKNELL American, 1837–1915

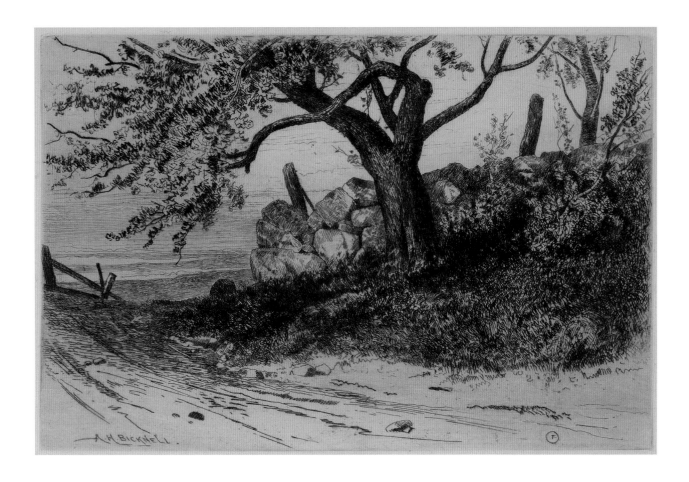

1

A Country Road, New England
ca. 1885

Although best known for his portraits and historical subjects, Albion Harris Bicknell also painted and etched still lifes and landscapes. Born in Turner, Maine, he spent most of his career in Boston, where he studied at the Lowell Institute in the 1850s. He became a member of the city's artistic brotherhood that included William Morris Hunt, Elihu Vedder, and John La Farge.

JAMES J. CALAHAN American, born 1841

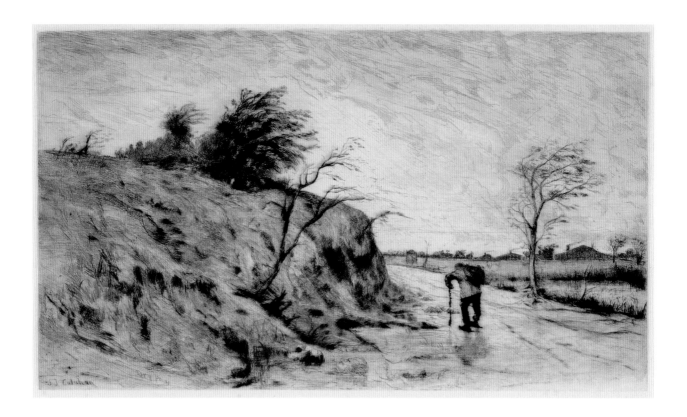

2

A March Wind
n.d.

Although little is known about this etcher, one could argue
persuasively that he was an artist in complete control of
his medium. This lovely drypoint, with its highly active
surface, brings to life the rawness of an early spring day,
especially in the poignant image of the stooped figure
bracing against the ferocious wind.

WILLIAM MERRITT CHASE American, 1849–1916

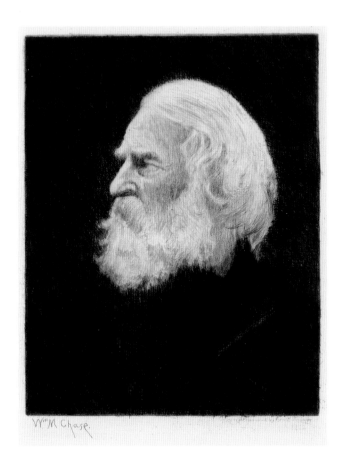

3

Henry Wadsworth Longfellow
ca. 1882

In 1882, Chase received a commission from The Art Interchange, a commercial publisher, to create a commemorative portrait of the poet Henry Wadsworth Longfellow (1807–1882). Longfellow was widely regarded as the greatest living American poet and his death was cause for national mourning; the publisher counted on a wide distribution and sale of the work, priced at fifty cents per sheet. Chase may have based the image on the well-known photograph of Longfellow taken in 1868 by the British photographer Julia Margaret Cameron (1815–1879). Though a relative neophyte in the world of etching, Chase shows a great affinity with the medium.

GABRIELLE DE VEAUX CLEMENTS American, 1858–1948

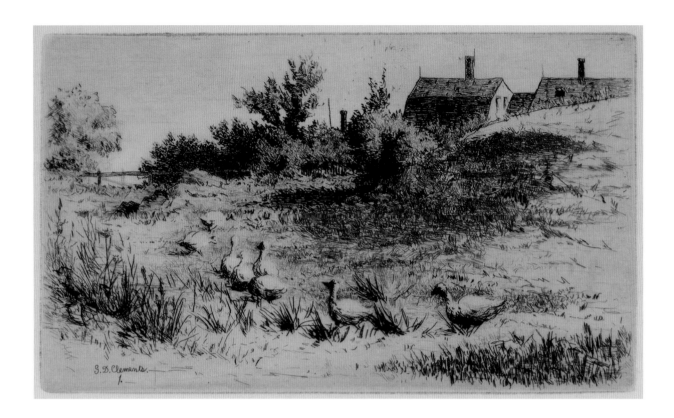

4

A Quiet Corner
ca. 1884

Clements was born in Philadelphia and studied in Paris at
the atelier of William-Adolphe Bouguereau (1825–1905).
A member of the Pennsylvania Academy of the Fine
Arts, she frequently spent summers at Cape Ann on the
Massachusetts coast. Known as a muralist and portrait
painter, Clements was also distinguished for her work in the
etching medium such as this tranquil summer scene.

SAMUEL COLMAN American, 1832–1920

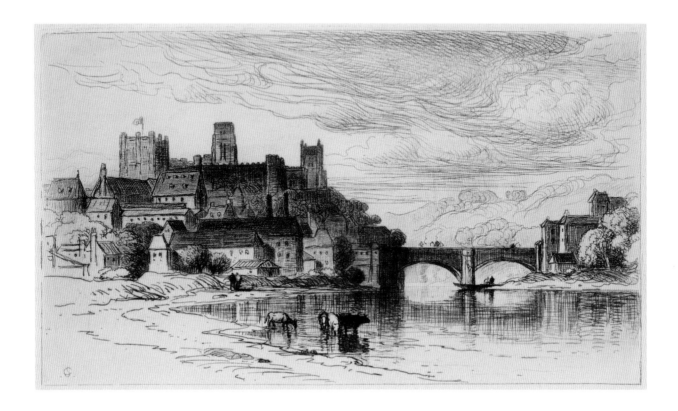

5

Durham, England
ca. 1880

Colman was a painter and designer who traveled the world
from Algeria to Point Lobos, California, in search of exotic
subjects. Less well-known for his etchings, he frequently
worked to great effect in the medium. The view of Durham
Castle and Cathedral from the River Wear proved to be
one of his most popular subjects.

REGINALD CLEVELAND COXE American, 1855–1926

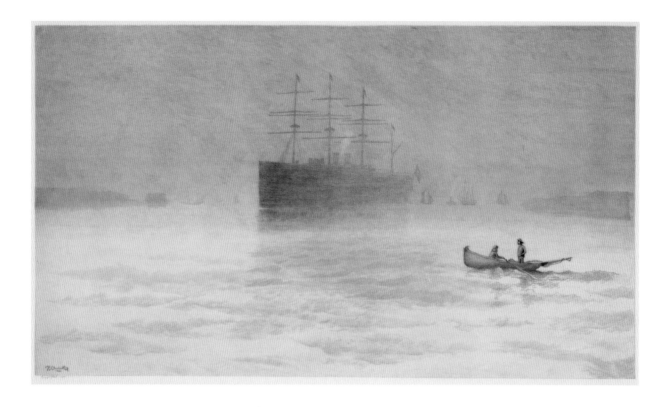

6

Untitled (Ships in Fog)
1886

Coxe, who lived in Buffalo, New York, had a summer
studio in Gloucester, Massachusetts, in an old farmhouse
at Eastern Point, directly on the harbor. His atmospheric
marine paintings brought him much recognition in the
1880s and he often transposed these into etchings that were
widely admired for their depiction of fog-shrouded ships.

HENRY FARRER American, born England, 1844–1903

7

Sunset Coast of Maine
1878

At the age of nineteen, Farrer emigrated to the United
States, following his older brother, Thomas Charles
Farrer (1839–1891), a Pre-Raphaelite painter in England,
who had moved here in the late 1850s. Little is known
about the younger Farrer's early training, but his precise
rendering of nature echoed the tenets of John Ruskin. He
was admired for the dramatic, atmospheric quality of his
land- and seascapes.

8

The Day is Ending, Night Descending
1886

Farrer was a president of the New York Etching Club and
did not shrink from the appetite amongst collectors for
larger and larger etchings. Although Whistler decried this
aggrandizing trend, the tonal subtleties in sky and snow
seen here prove that the large plate, in the hands of a gifted
etcher, is no impediment to beauty.

HENRY FARRER American, born England, 1844–1903

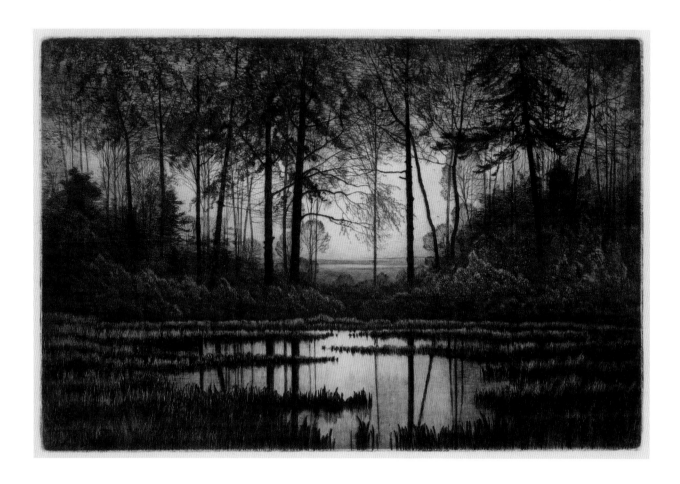

9

Moonrise
ca. 1889

Farrer was one of the first American artists to take
up etching, inspired by an exhibition of modern
French painter-etchings in New York in the late 1860s.
Throughout the years of his long engagement with the
medium, he developed techniques for expressing exquisite
line and tone. Depictions of the passing light of day into
night, as seen in works titled *Sunset*, *Twilight*, and, here,
Moonrise, held particular appeal for him.

HARRY FENN American, born England, 1845–1911

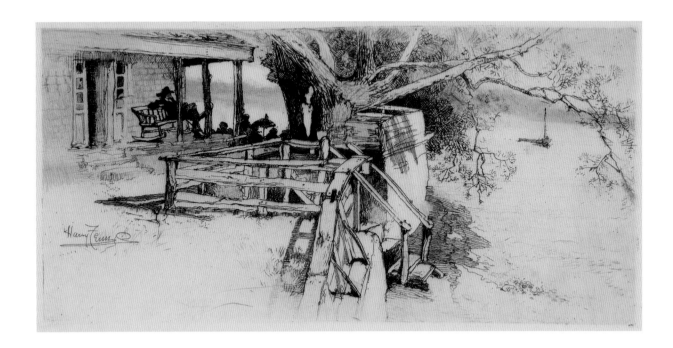

10

Lobster Cove
ca. 1889

Fenn was best known as an illustrator and etcher. He was
one of the artists chosen to work on *Picturesque America*,
the large compendium (over 900 illustrations) of sights and
scenes across the continent, published in 1872 and 1874,
under the editorship of William Cullen Bryant. *Lobster Cove*
shows Fenn's skill in capturing a sense of place.

STEPHEN JAMES FERRIS American, 1835–1915

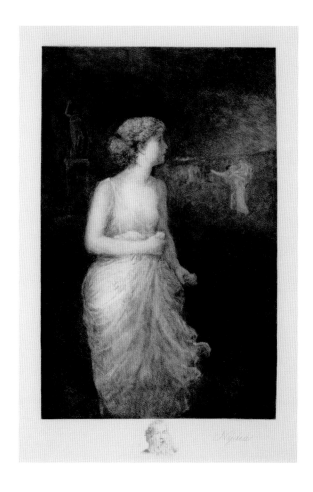

11

Nydia (after George Fuller)
1883

Nydia, the Blind Girl of Pompeii, was the heroine of Edward Bulwer-Lytton's *The Last Days of Pompeii* (1834) and a character that captured the imagination of artists for decades, including the well-known Randolph Rogers, who made a marble statue of Nydia in 1855 and Tonalist George Fuller, who made her the subject of an 1882 painting, which Ferris admired. Ferris, who studied at the Pennsylvania Academy of the Fine Arts and also at the atelier of Jean-Léon Gérôme in Paris, was an influential painter and teacher and was married to Elizabeth Moran, sister of Thomas and Peter Moran. Ferris's etching of Nydia forcefully demonstrates that a "reproductive" etching can be a creative work in its own right.

R. SWAIN GIFFORD American, 1840–1905

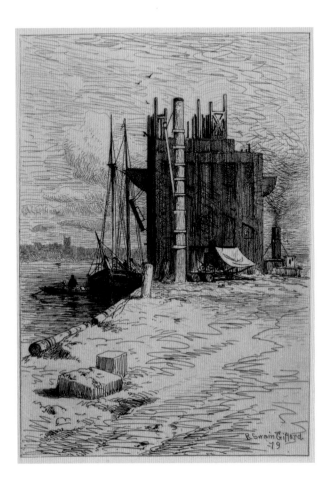

12

Coal Pockets at New Bedford
1879

Gifford was born in New Bedford, Massachusetts, and kept a summer studio there. A founding member of the New York Etching Club, he was one of the few in that group who had extensive experience with the medium before the club's establishment in 1877. Gifford made numerous etchings of the landscape and wetlands near New Bedford. Here he brings his keen powers of observation to a coal-storage bin on the New Bedford waterfront and makes it a compelling subject.

R. SWAIN GIFFORD American, 1840–1905

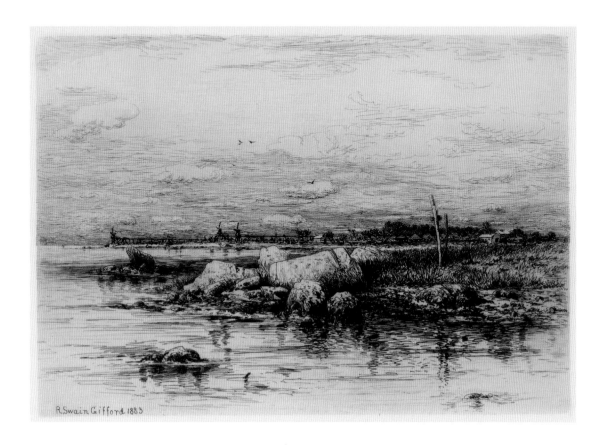

13

The Mouth of the Apponigansett
1883

The critic Mariana G. van Rensselaer singled out Gifford
for special praise when she wrote that he was one "who
etches more truly in the etcher's spirit; who knows so
exactly what to omit and what to insist upon, and thus
produces such complete effects by such simple and
synthetic means."

R. SWAIN GIFFORD American, 1840–1905

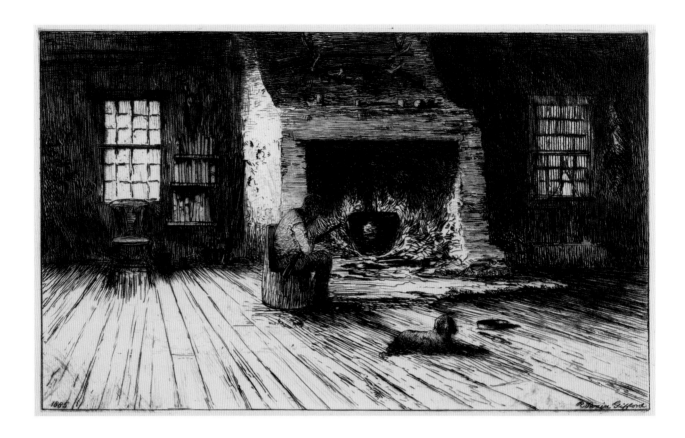

14

Untitled (Interior, Man Cleaning Gun by Fireplace)
1885

This genre scene afforded Gifford the opportunity to
display his prodigious technical skills in the darkened
interior contrasted with light from the windows and the
glowing fireplace.

CLEMENT R. GRANT American, 1849–1893

15

Watching and Waiting
ca. 1888

Clement Rollins Grant was known primarily as a figure painter and maintained a studio in Boston. A trip to England and France when he was eighteen made a deep impression, especially the work of Manet, which he saw there. In this work, a narrative is strongly implied by the title, but it is left to the viewer to supply the story of this lovely and hopeful young woman.

16

Untitled (Girl in Field, Waving Handkerchief)
ca. 1889

THOMAS HOVENDEN American, born Ireland, 1840–1895

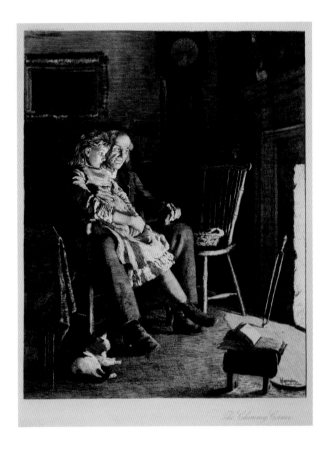

17

The Chimney Corner
ca. 1886

Hovenden emigrated from Ireland to the United States at the age of twenty-three. From 1874 to 1880 he studied in Paris at the École des Beaux-Arts with Alexandre Cabanel (1823–1889) and spent much time at the village of Pont-Aven in Brittany with the American artist Robert Wylie. Hovenden became known for historical tableaux, like *The* *Last Moments of John Brown* (1882–1884), and for genre paintings and etchings of sentimental subjects, like *The Chimney Corner.*

THOMAS HOVENDEN American, born Ireland, 1840–1895

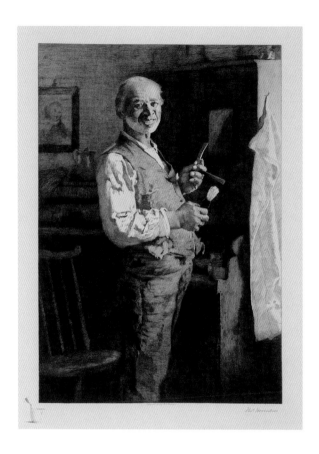

18

Untitled (Man Shaving)
1886

Hovenden taught at the Pennsylvania Academy of the
Fine Arts alongside contemporaries Thomas Eakins
and Thomas Anschutz and acquired a reputation as an
influential instructor. His realistic depictions of everyday
life won him wide acclaim. He was a staunch abolitionist
and in his work often depicted with great sensitivity
African-American subjects in domestic settings.

GERTRUDE RUMMEL HURLBUT American, active 1880s–1909

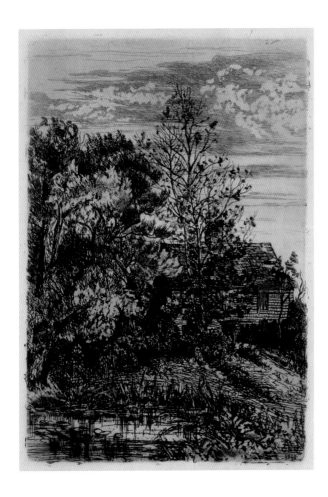

19

Near East Hampton, L.I.
1880

By the 1880s, the East End of Long Island was accessible by the Long Island Rail Road and many artists, like Hurlbut, came to sketch the pastoral scenery. Her work was included in an 1888 exhibition at the Union League Club of New York that included over 500 prints by thirty-five women artists, *Work of the Women Etchers of America*.

In an introduction to the catalogue, the critic Mariana G. van Rensselaer noted: "It would be a singularly incomplete collection of American etchings that should contain no plates with a feminine signature."

HUGH BOLTON JONES American, 1848–1927

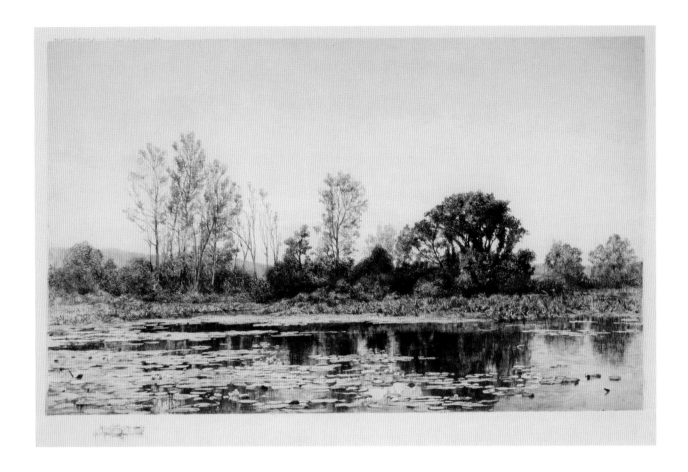

20

Untitled (Lake Scene with Lily Pads)
ca. 1889

Jones, a native of Baltimore, began his studies at the
Maryland Institute in the early 1860s and his painting
reflected the dominant style of the Hudson River School.
In 1876 he joined his friend and fellow artist Thomas
Hovenden in Pont-Aven and for the first time worked *en
plein air*. The work he did after returning to the United
States in 1880 reflects this change.

JAMES S. KING American, 1852–1925

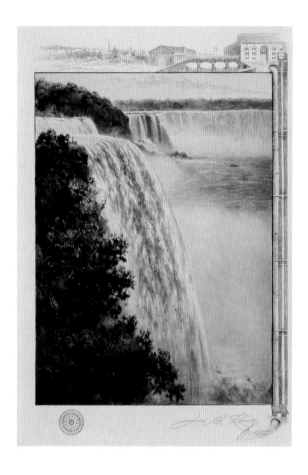

21

Electric Power, Niagara Falls
ca. 1896–1900

After the etching revival faded, a few artists, like King, remained active as commercial engravers. *Electric Power* was a supplementary illustration to Hubert H. Bancroft's ten-volume work, *Achievements of American Civilization, The Book of Wealth* (1896-1900). King's composition focuses on the powerful cascade falls and includes in the margin a remarque that alludes to the channeling of the falls for electric power. With no sense of mourning for the loss of America's innocence, King's etching described, in Bancroft's words, "the operation of a mighty force which has wrought inestimable benefits to the human race."

HENDRIK-DIRK KRUSEMAN VAN ELTEN Dutch, 1829–1904, to United States 1865

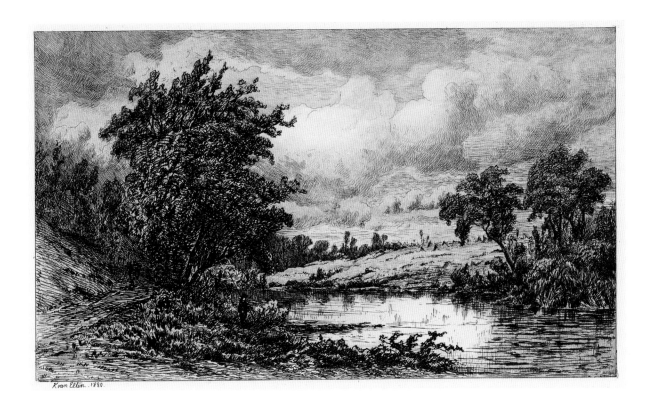

22

On the Shepang River, Conn.
1880

Kruseman van Elten took up etching late in his career. As a young man he had studied landscape painting in Holland and later distinguished himself in America, becoming an Associate at the National Academy of Design in 1871 and Academician in 1883. Well-acquainted with the French and English etching revivals and, of course, the graphic work of Rembrandt, he frequently etched his plates directly from nature.

HENDRIK-DIRK KRUSEMAN VAN ELTEN Dutch, 1829–1904, to United States 1865

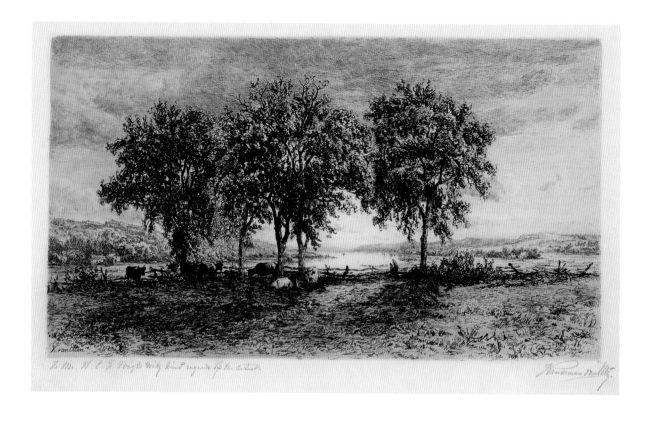

23

In the Grove
ca. 1882

BENJAMIN LANDER American, 1842–1907

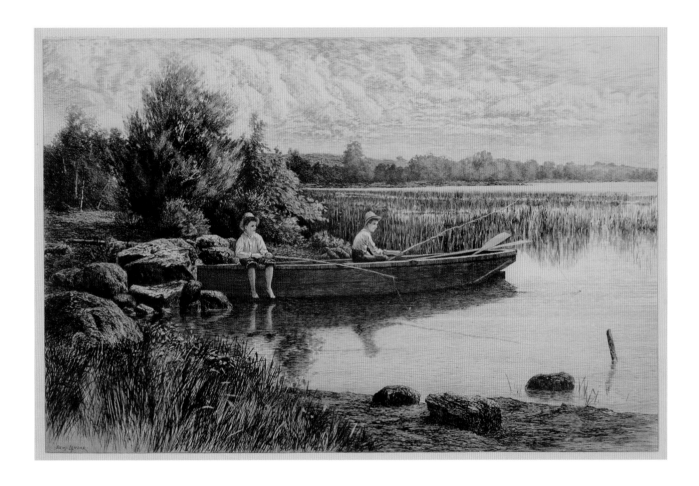

24

When We Were Boys
ca. 1885

Although he was not an official member of the New York Etching Club, Lander exhibited frequently with that group. His etchings were popular with collectors for their meticulous attention to detail and tone and unabashedly sentimental subject matter. Artists frequently employed the seasons as metaphors for the stages of human life. Summer, youth and its attendant pleasures were often Lander's subject.

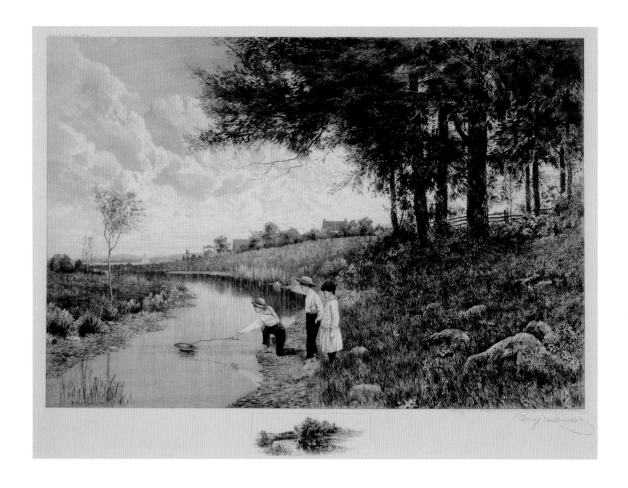

25

On the Bay

ca. 1886

BENJAMIN LANDER American, 1842–1907

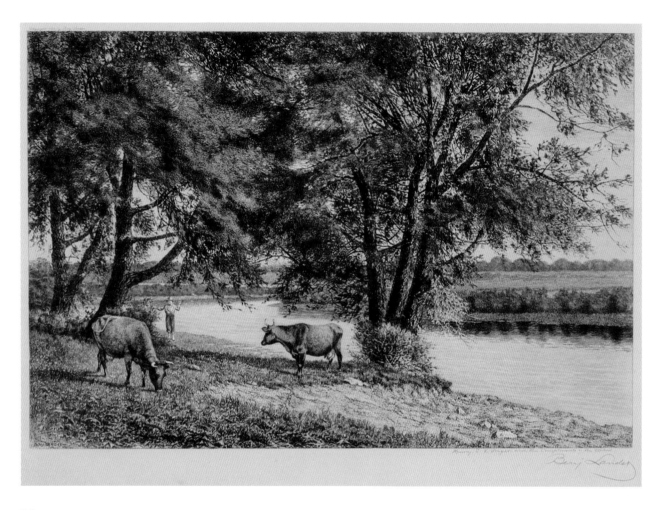

26

Under the Willows
1887

WILLIAM HENRY LIPPINCOTT American, 1849–1920

27

Stolen Moments
1888

Lippincott began his formal art training at the Pennsylvania Academy of the Fine Arts and initially studied to become an illustrator. He later spent eight years in France, where he studied and painted with other young Americans in Paris. In this charming etching, a woman has set aside her embroidery to steal a glance at a novel.

Romantic yearnings are also alluded to in the chivalric images appearing in the remarque and by the Spanish tortoiseshell comb in her hair.

S. C. McCUTCHEON American, active 1880s

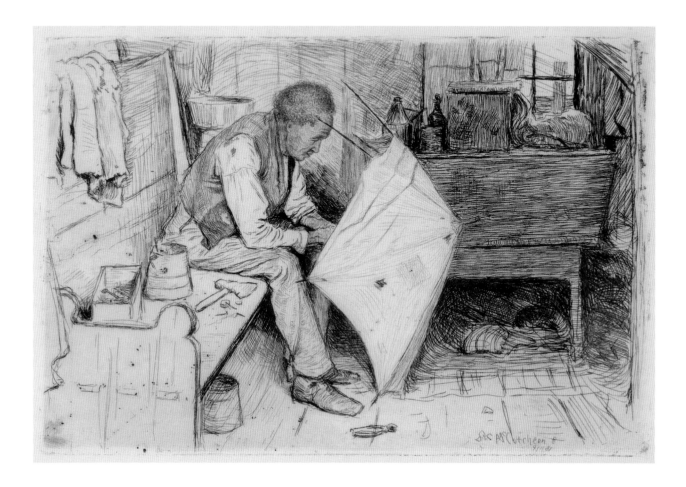

28

Old Friends

1881

McCutcheon was a painter and etcher known for his sympathetic genre scenes, like this touching portrait of an elderly man absorbed in his task.

CHARLES F. W. MIELATZ American, born Germany, 1864–1919

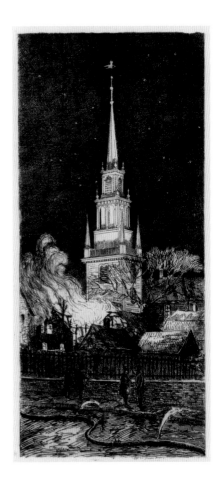

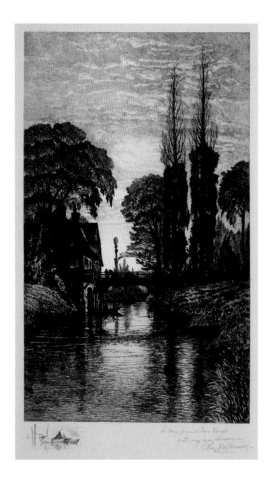

29

Trinity Church Steeple During a Conflagration
1885

Mielatz, who was born in Germany and came to the United
States as a child, studied at the Chicago School of Design
and later served as a draftsman in the U.S. Engineering
Corps, where he learned to make maps using the etching
technique. Known for his work with architectural subjects,
in this print he depicts an 1885 fire in buildings surrounding
historic Trinity Church, Newport, Rhode Island.

30

Narragansett Mill Pond
1886

JOHN AUSTIN SANDS MONKS American, 1850–1917

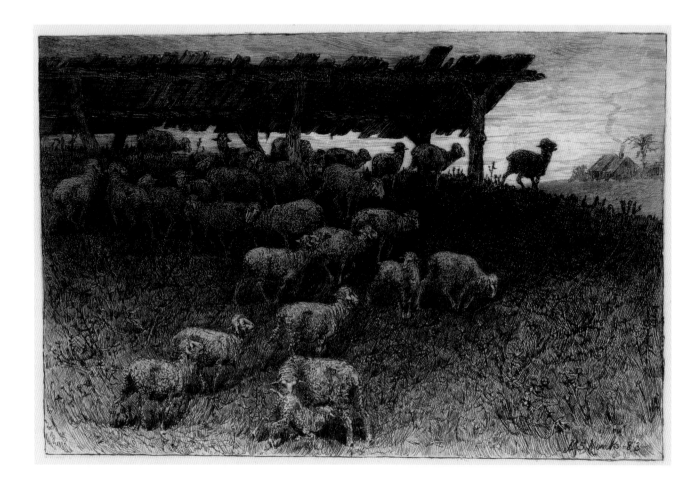

31

Twilight

1883

Monks clearly admired the animal paintings of the
French Barbizons and the work of seventeenth-century
Dutch masters. He first studied sheep "as an accessory
to landscape," as he put it, but his evident affection
for the wooly creatures won out and his name became
synonymous with sheep. This print, with its striking
effects of dark and light tonalities, is evidence of Monks's
mastery of the medium.

JOHN AUSTIN SANDS MONKS American, 1850–1917

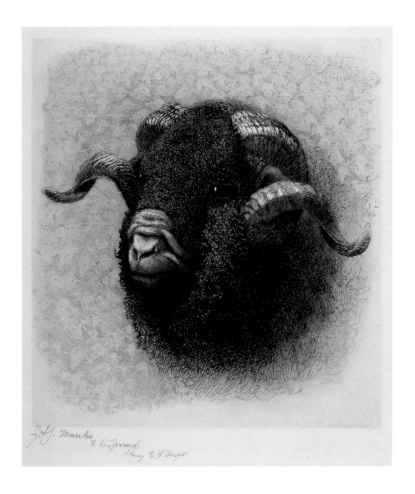

32

The Patriarch
ca. 1885

The head of this Merino ram, astonishing for its near-
photographic rendering, is surrounded by a halo formed of
his miniscule progeny. Monks enjoyed great success with
his etchings of sheep and kept a small flock of them in a
corral visible from his studio windows.

MARY NIMMO MORAN American, born Scotland, 1842–1899

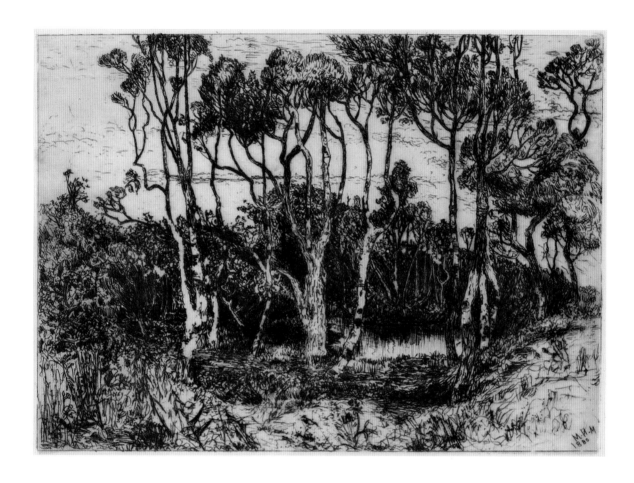

33

Solitude

1880

Mary Nimmo and Thomas Moran were married in 1862. She always said that she took up painting with the thought of making herself a "better companion," and Moran welcomed her criticism of his work, adding that she was "always right." When Thomas introduced her to etching in 1879, she immediately took to the medium and soon became one of the most admired, and successful, American painter-etchers and one of the few women members of etching societies both in the U.S. and Britain. The Morans began to summer on the East End of Long Island in 1878. They settled in East Hampton, which reminded them of the charming villages they had known as children.

MARY NIMMO MORAN American, born Scotland, 1842–1899

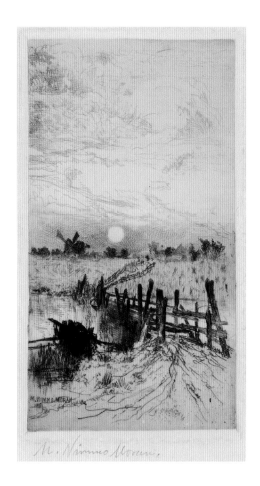

34

Evening—Easthampton
1881

MARY NIMMO MORAN American, born Scotland, 1842–1899

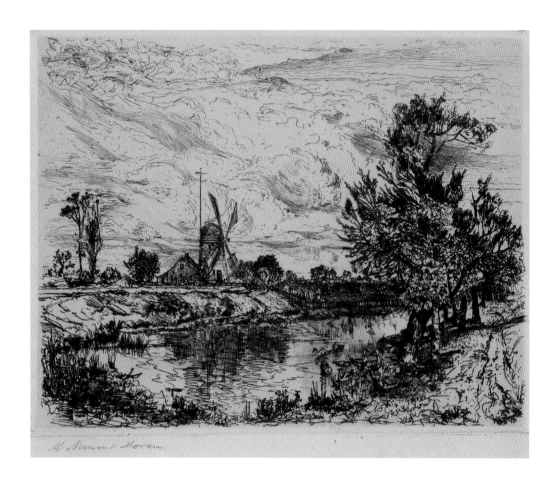

35

The Goose Pond—Easthampton
1881

MARY NIMMO MORAN American, born Scotland, 1842–1899

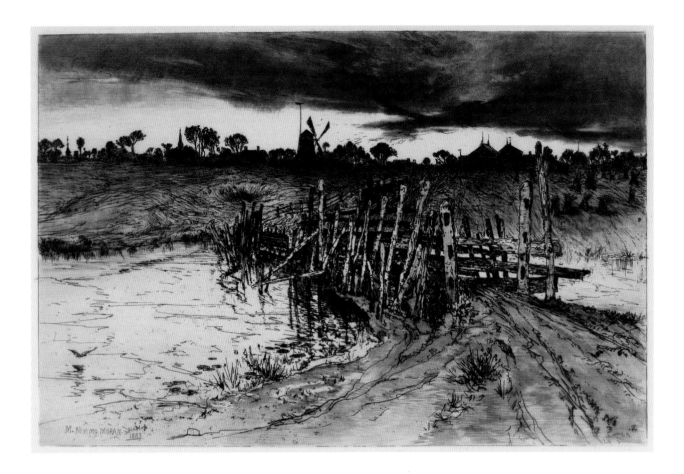

36

"'Tween the Gloaming and the Mirk"
1883

Although the print depicts Hook Pond in East Hampton,
its title is taken from an old Scottish song referring to the
time between twilight and nightfall when the cows come
home. This was one of Mary Moran's most admired and
sought-after prints.

MARY NIMMO MORAN American, born Scotland, 1842–1899

37

Georgica Pond—Looking Seaward
1885

MARY NIMMO MORAN American, born Scotland, 1842–1899

38

Home Sweet Home
1885

The cottage of John Howard Payne (1791–1852), the author
of the popular song "Home Sweet Home," was directly
across from the Moran homestead in East Hampton and a
rich part of the colonial history of the village.

MARY NIMMO MORAN American, born Scotland, 1842–1899

39

"Where Through the Willows Creaking Loud, is Heard the Busy Mill"
1886

This etching is a larger, more formal elaboration of Mary
Moran's *The Goose Pond*. In 1881, it was selected as her
diploma work by the London Society of Painter-Etchers.

PETER MORAN American, born England, 1841–1914

40

On the Road to Santa Fe
ca. 1885

PETER MORAN American, born England, 1841–1914

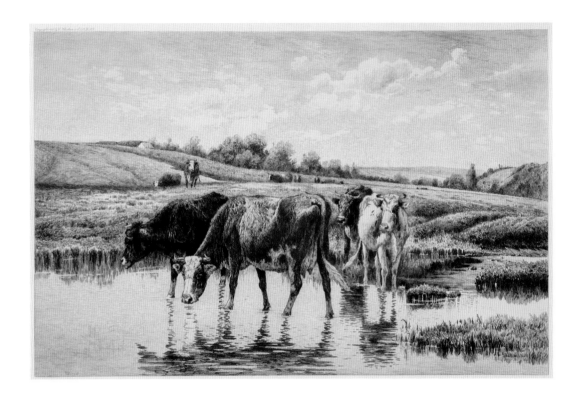

41

Untitled (Cows in Field)
ca. 1886

Peter Moran was Thomas Moran's youngest brother. He was
a pioneer in the etching revival, and one of the first American
artists to take up the medium. It was he who taught Stephen
Parrish how to etch. Moran became justly famous for his
paintings and etchings of cattle executed in the manner of
the French Barbizon painters whom he greatly admired.

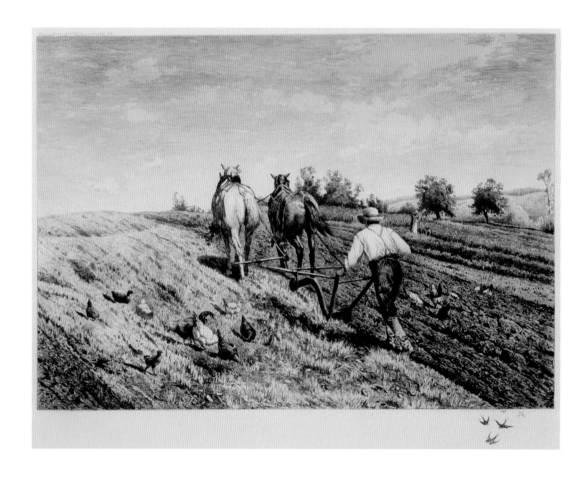

42

Untitled (Man Plowing Field)
ca. 1886

PETER MORAN American, born England, 1841–1914

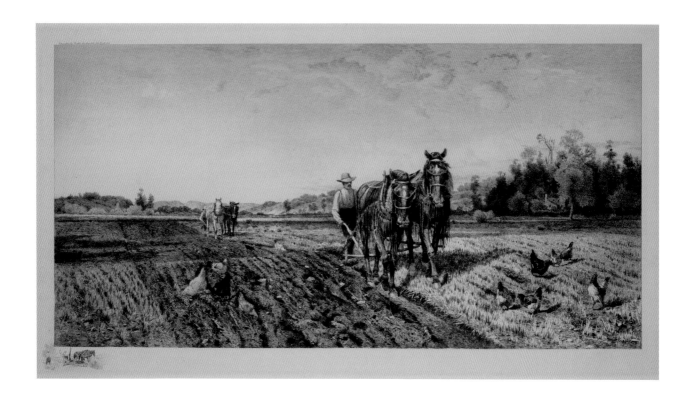

43

The Ploughman
ca. 1887

THOMAS MORAN American, born England, 1837–1926

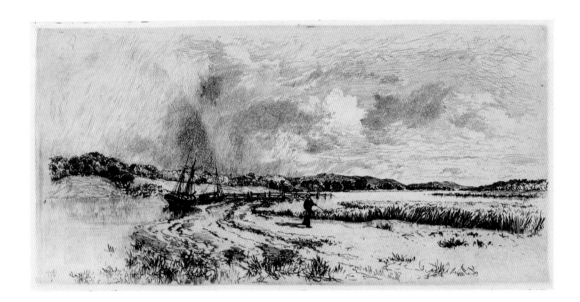

44

The Rainbow
1880

Thomas Moran was born in England and brought to the United States as a young boy when the family settled near Philadelphia. He was apprenticed to an engraving firm and later began to work in the studio of his older brother Edward, also an aspiring artist. The brothers traveled to England in 1862 and made sketches after Turner—a profound influence on Moran's work. In 1871 he made his first expedition to the western United States and would spend much of his career painting the great, open spaces of that region.

THOMAS MORAN American, born England, 1837–1926

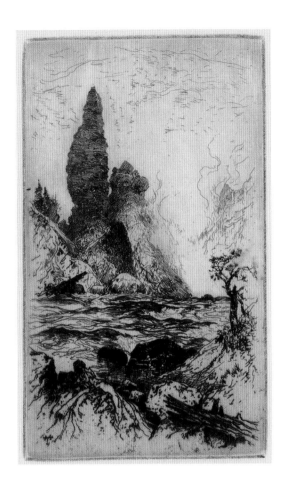

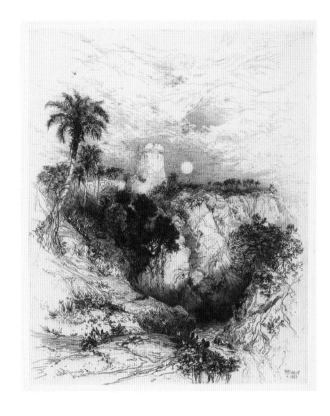

45

Tower Falls
1880

The view is from Moran's 1871 Yellowstone trip with the Hayden expedition.

46

A Tower of Cortez—Mexico
1883

In 1883 Moran traveled to Mexico. He wrote in his diary that the tower was located "on the road between Vera Cruz and the City of Mexico, near a point called Paso del Macho, on the edge of a deep canyon of lava rocks, much overgrown by vegetation peculiar to the Tierra Caliente or Hot Land." Moran made sketches that he later used for the etching.

THOMAS MORAN American, born England, 1837–1926

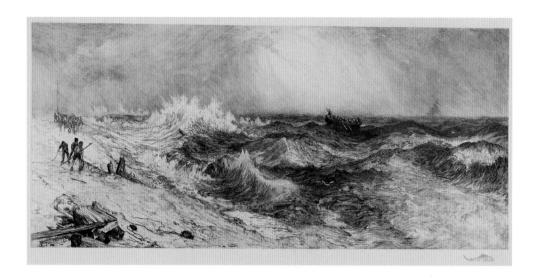

47

The Much Resounding Sea
1886

In 1884, Moran built a house and studio in East Hampton.
Called "The Studio," it was a gray-shingled, hip-roofed
building from a plan that he drew up himself, with one
large 40 x 25 foot room that was a combined parlor and
studio. *The Much Resounding Sea* is a reproductive print
after his own painting of the same name (1884).

THOMAS MORAN American, born England, 1837–1926

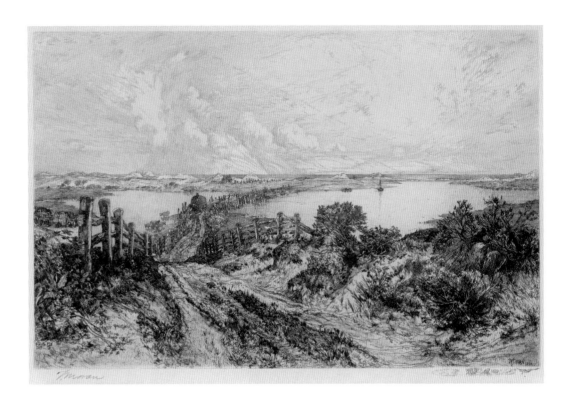

48

Morning
1886

This print is also known as *Hook Pond, Easthampton* or
Morning on the Coast, Easthampton, L.I. In 1886 the work
received first prize in a national etching competition held
by The Rembrandt Club. It is a strong example of Moran's
consummate skill as an etcher.

THOMAS MORAN American, born England, 1837–1926

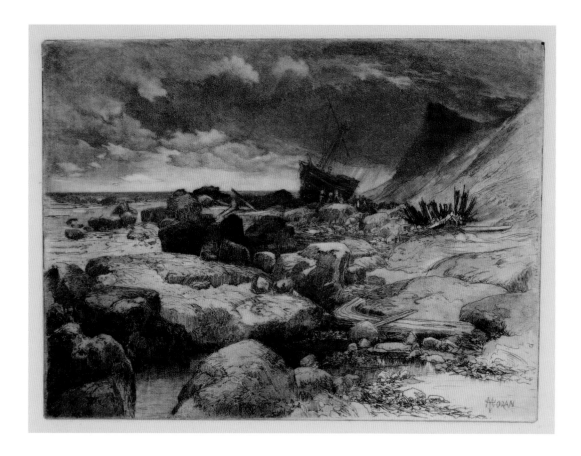

49

A Wreck—Montauk
1886–1888

Wrecked ships were favorite subjects for artists on Long Island. The subject of this etching, however, probably does not represent any identifiable incident.

THOMAS MORAN American, born England, 1837–1926

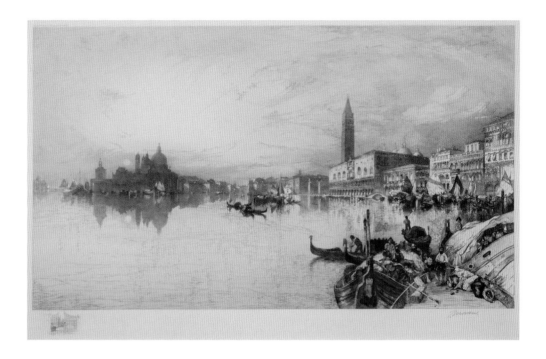

50

The Gate of Venice
1888

Moran first visited Venice in May 1886. In a letter to
Charles Klackner, who published the print, Moran wrote:
"Venice is an inexhaustible mine of pictorial treasures for
the artist and of dreamy remembrances to those who have
been fortunate enough to visit it, and so it will continue to
be as long as it exists and the human mind finds enjoyment
in the picturesque and the beautiful."

THOMAS MORAN American, born England, 1837–1926

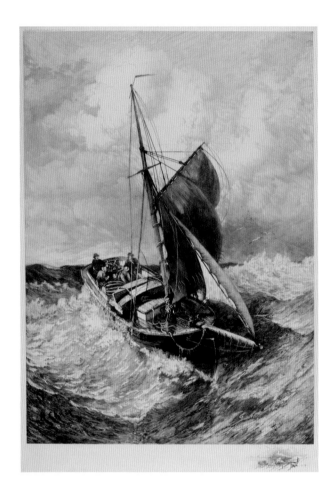

51

Untitled (Fishing boat on storm-tossed sea; after Harry Chase)
1890

It may seem curious that Thomas Moran, an established artist in many media and certainly a preeminent painter-etcher, would undertake to reproduce the work of another artist, but such was the nature of commercial printing that these endeavors were often more lucrative, for the artist and the publisher, than original works. Chase was a popular marine painter and the dramatic subject must have had great appeal for Moran; this print is on the same impressive scale as *The Gate of Venice* (1888).

JAMES CRAIG NICOLL American, 1846–1918

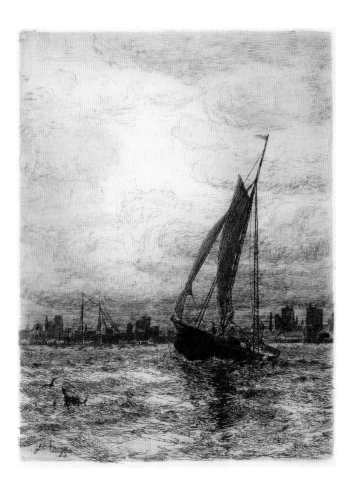

52

In the Harbor

1882

JAMES CRAIG NICOLL American, 1846–1918

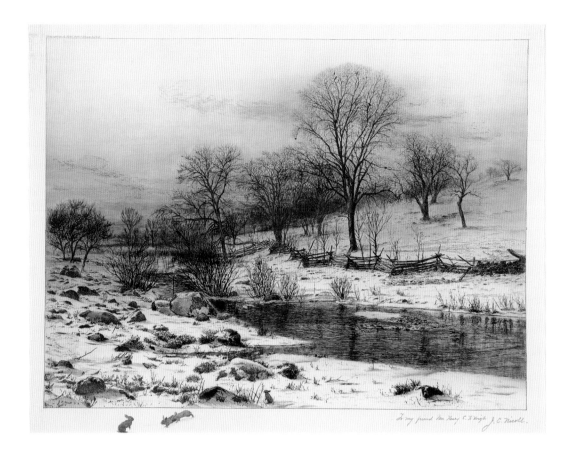

53

A Winter Morning
ca. 1887

Nicoll missed the first meeting of the New York Etching
Club because he could not wait to get to his country place
in Shrub Oak, Westchester County. According to his diary
entry that day, the club could wait; he had gladiolus bulbs to
plant and hens to set. His love of the countryside is evident
in the close observation of nature in this wintry scene.

STEPHEN PARRISH American, 1846–1938

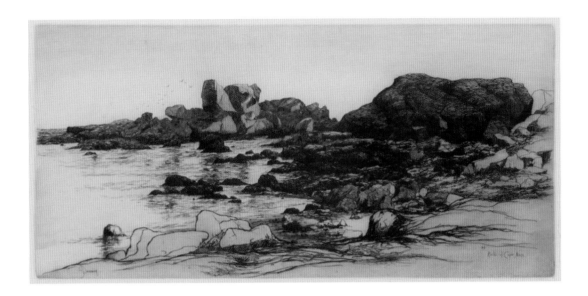

54

Rocks of Cape Ann
1881

Created only two years after receiving his first
instruction in the etching technique, *Rocks of Cape Ann*
shows Parrish's natural affinity with the medium. He
has taken an unremarkable stretch of shoreline and,
with amazing control of the etched line, created dense
areas of shadow.

STEPHEN PARRISH American, 1846–1938

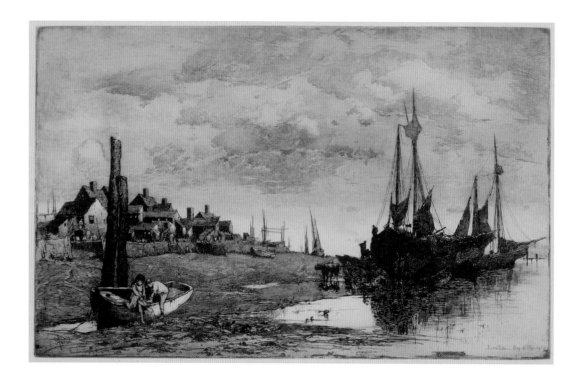

55

Low Tide—Bay of Fundy
1882

Planning for a summer sketching trip to the Canadian
Maritime Provinces, Parrish wrote to S. R. Koehler that he
was becoming "more and more 'enthused' all the time, and
with what I hear from other sources about. . .the strange
shore effects of the Bay of Fundy at low tide &c. I anticipate
a treat to say the least of it."

STEPHEN PARRISH American, 1846–1938

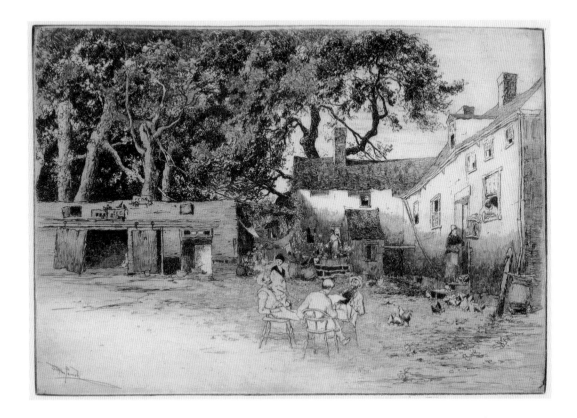

56

An Old Acadian Inn Yard
1882

Parrish's high expectation of picturesque sketching sites in Canada was more than rewarded. This etching, of an inn in a French-Canadian village, shows the artist, seated on the left, and Charles Adams Platt, seen from the back, who accompanied Parrish on the trip. The transparency of the lightly sketched figures suggest that Parrish was thinking of Whistler's Venetian etchings, which he would have most likely seen when they were exhibited in Philadelphia in 1881.

STEPHEN PARRISH American, 1846–1938

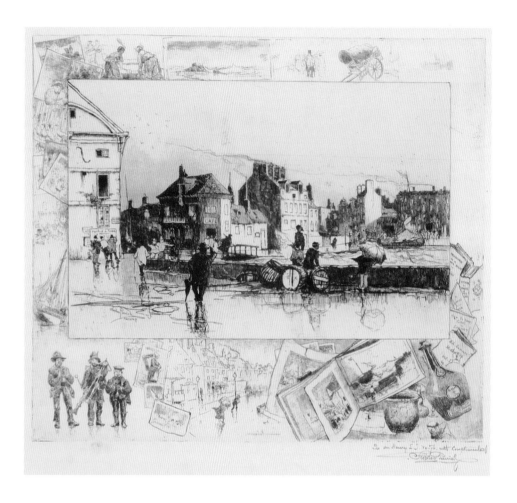

57

A Gale at Fécamp (Normandie)
August 1886

Parrish made this etching after a summer trip to France and a visit to Fécamp on the Normandy coast. The numerous large remarques suggest that Parrish has incorporated some of the "marginalia" drawings that filled his travel diaries. The etching can also be read as an homage to the well known French etcher Félix Buhot (1847-1808), whose work Parrish would have seen and who used the same device of a central composition surrounded by numerous sketches.

STEPHEN PARRISH American, 1846–1938

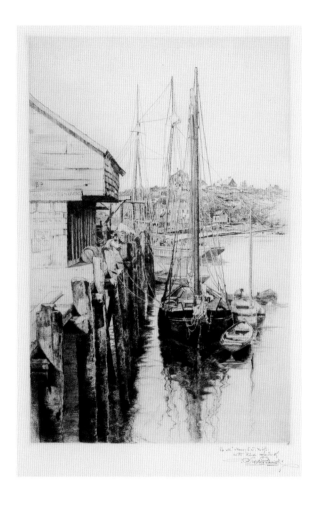

58

A Gloucester Wharf
1886

Parrish was especially proficient with the drypoint
technique in which lines are drawn directly on the
plate with a needle. The incised lines of a drypoint are
shallower than those in an etching, and in this technique
the burr is not scraped away before printing, resulting in
a heavier, softer-looking line. His masterful use of this
technique can be observed in the liquid blacks around the
base of the pilings in the water and the hull of the boat.

STEPHEN PARRISH American, 1846–1938

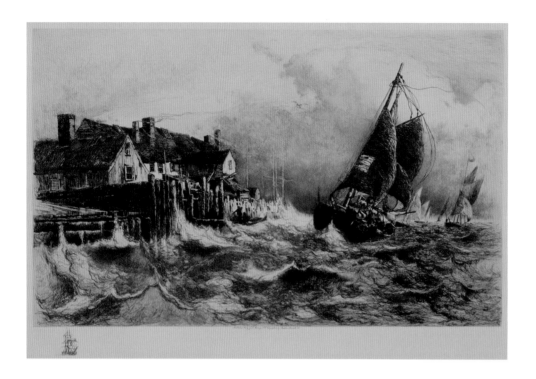

59

A Squall—Bay of Fundy
1888

CHARLES ADAMS PLATT American, 1861–1933

60

Provincial Fishing Village
1882

On a summer vacation with Stephen Parrish and his family in 1880, nineteen-year-old Charles Adams Platt, then a student at the National Academy of Design, was taught the etching technique that Parrish had learned the previous year from Peter Moran. The talented young artist, who would distinguish himself as an architect and landscape designer as well, took to the medium and accompanied Parrish on a sketching trip to the Canadian Maritime Provinces the following summer. This etching was made from that trip.

CHARLES ADAMS PLATT American, 1861–1933

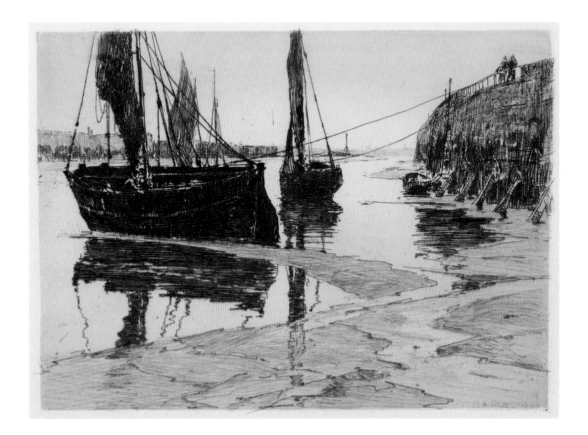

61

Low Tide, Honfleur
1887

Platt studied in Paris from 1882 to 1889 and often visited
the seaport town of Honfleur, on the estuary of the Seine,
where this etching was made. The subject recalls one that
he and Parrish sketched when at the Bay of Fundy.

HENRY M. ROSENBERG American, 1858–1947

62

Untitled
1889

Rosenberg was born in New Jersey and studied in Munich with the artist Frank Duveneck. He accompanied Duveneck and some dozen other students to Venice in 1880, where they met James McNeill Whistler, who was working on a series of etchings. The young men were known collectively as the Duveneck Boys.

GEORGE HENRY SMILLIE American, 1840–1921

63

Untitled (Man and Woman Reclining on River Bank)
1881

George Henry Smillie's father James Smillie (1807–1885),
a Scottish engraver, emigrated to New York in 1829, and
was elected to the National Academy of Design in 1851.
The younger Smillie's ability to sketch on the plate and
have this quality reflected in the final print is well shown
in this example.

GEORGE HENRY SMILLIE American, 1840–1921

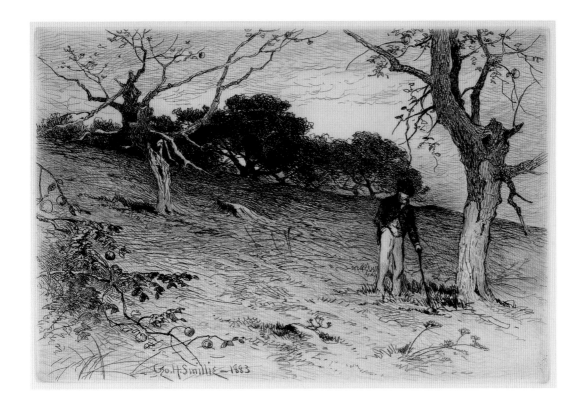

64

Old New England Orchard
1883

This work was likely executed near Marblehead,
Massachusetts, where Smillie and at least one other
painter-etcher, James Craig Nicoll, spent much time. An
article on artists' summer haunts that appeared in *The
Century* in 1885 described Smillie as "identified with
Marblehead," and noted for the way "he paints trees and
rocks as the masters of genre paint aged men and women,
making every wrinkle and scar tell a story."

JAMES DAVID SMILLIE American 1833–1909

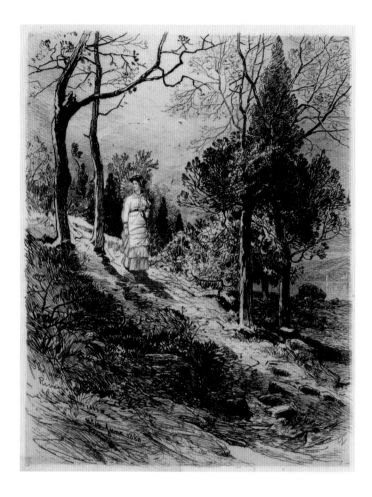

65

The Way to the River
1880

JAMES DAVID SMILLIE American, 1833–1909

66

Rough Sport in the Yosemite
1886

James Smillie was an organizer and later president of
the New York Etching Club. He and his brother, George
Henry Smillie, both studied with their father, an engraver.
Smillie traveled to Yosemite in 1871. This etching was
preceded by both an oil and a watercolor of the subject.

CHARLES WALTER STETSON American, 1858–1911

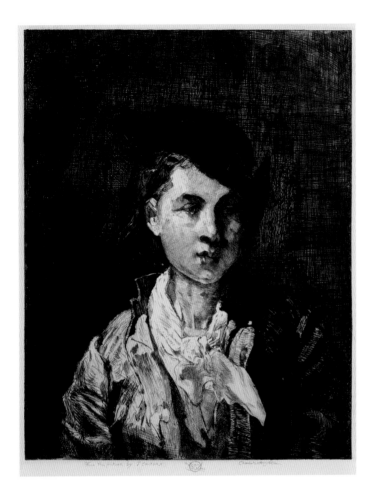

67

Gamin (after Thomas Couture)
1884

Stetson was a self-taught printmaker from Rhode Island. In 1883, the Boston collector Beriah Wall commissioned Stetson to etch copies of the modern French masters in his paintings collection for a catalogue. This led to a subsequent proposal for twelve large-scale etchings from the paintings, a project that occupied Stetson for well over a year and began to wear his patience. He wrote in his diary, "I was not made a reproductive etcher. . .There is little love in it truly. To strive day after day to express another man's thought when I have burning thoughts of my own to say is not cheerful by any means."

JOHN HENRY TWACHTMAN American, 1853–1902

68

Autumn, Avondale
ca. 1879

A well-known painter, Twachtman was equally adept in
the etching medium, which was perfectly suited to his
use of expressive line. By 1879, Twachtman was exhibiting
his etchings at the Museum of Fine Arts, Boston, and
joined the Etching Club of Cincinnati when he returned
to his hometown. The etching retains the immediacy and
vibrancy of a *plein-air* sketch and is distinctive for the
broad areas devoid of line.

AUGUSTUS D. VAN CLEEF American, 1851–1918

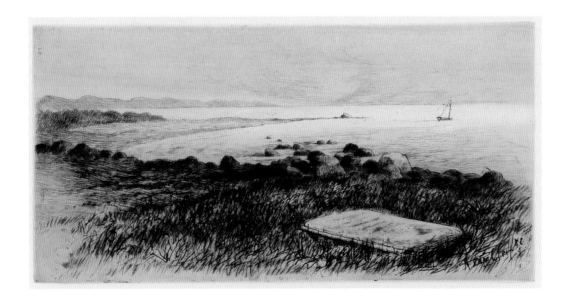

69

The Tomb of a Modern Leander, Fisher's Island
1882

Leander was the young Greek who repeatedly swam the Hellespont to meet his beloved Hero, priestess of Aphrodite, and was drowned one stormy night. No inscription can be read on the stone in this etching, but the title clearly tells us that there had been a drowning in the Long Island sound, off Fisher's Island. The modern-day namesake must have had a love as well: her profile appears like an apparition in the lower-left corner of the plate.

CHARLES A. VANDERHOOF American, born 1918

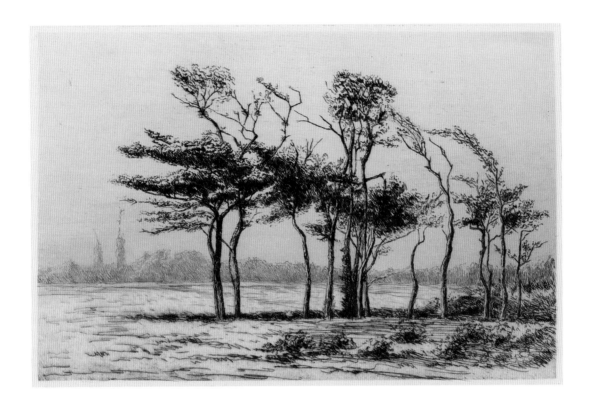

70

Sand Dunes, Virginia
ca. 1892

Vanderhoof has employed the drypoint technique to great
effect in this expressive study of sand dunes in Virginia,
bringing to mind the phrase of critic Alfred Trumble:
"…etching should express an idea by the perfection of its
suggestiveness and at the least expenditure of labor."

THOMAS WATERMAN WOOD American, 1823–1903

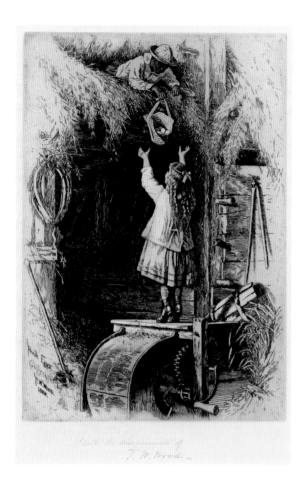

71

Fresh Eggs
1882

Wood was born in Montpelier, Vermont, and in the mid-1840s studied briefly with the noted Boston portrait painter Chester Harding. Wood's genre paintings and character studies became widely known in the postwar decades, especially images of those freed slaves who had fought for the Union cause. He continued to find great success with paintings on themes drawn from African-

American life and often produced etchings of those works, as seen in *Fresh Eggs*, based on his 1881 painting of the same subject.

THOMAS WATERMAN WOOD American, 1823–1903

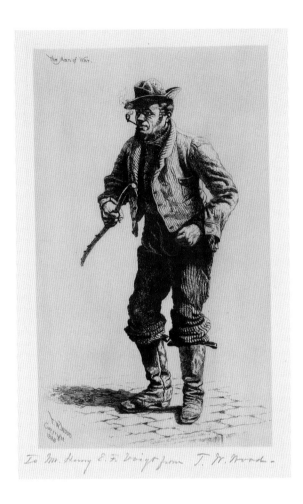

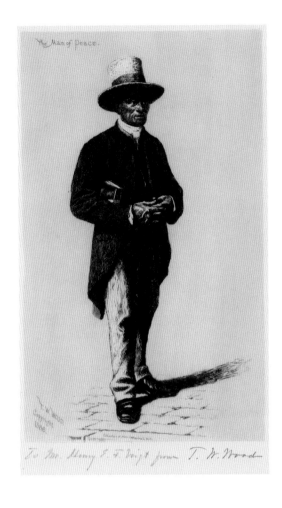

72

The Man of War
1886

73

The Man of Peace
1886

The Man of War and *The Man of Peace* are splendid examples
of Wood's keen interest in the depiction of character
and reflect his early experience as a portrait painter. The
etchings were variations on themes that he had explored
some years before. The shillelagh-bearing Irishman was
taken from the watercolor *American Citizens (To the Polls,
1867)*. The figure of the preacher was from a watercolor
that Wood had made some ten years earlier; the model was
Henry Smith, an African-American barber whom Wood
knew from his hometown of Montpelier, Vermont.

CATALOGUE CHECKLIST

All works are in the collection of the Parrish Art Museum. Dimensions are given in inches; height precedes width.

1. **Albion H. Bicknell** (American, 1837–1915)
 A Country Road, New England, ca. 1885
 Etching, plate: 6 ⅛ × 9 ¼; sheet: 7 ¹¹⁄₁₆ × 10 ⅞
 Signed in plate, l.l.: A.H.BICKNELL.; inscribed in plate,
 l.r.: T: in margin and on mat in pencil, l.r.:
 For my Collection/Henry E.F. Voigt
 Dunnigan Collection, 1976.1.222

2. **James J. Calahan** (American, born 1841)
 A March Wind, n.d.
 Drypoint, plate: 6 ⅞ × 11 ¹⁵⁄₁₆; sheet: 14 ¾ × 19 ⁵⁄₁₆
 Signed in plate, l.l.: J.J.Calahan; inscribed in plate, l.l.:
 Dry Point
 Dunnigan Collection, 1976.1.79

3. **William Merritt Chase** (American, 1849–1916)
 Henry Wadsworth Longfellow, ca. 1882
 Etching, plate: 8 × 6 ⅜, sheet: 21 × 16 ¼
 Signed in plate, l.l.: Wm M Chase; inscribed in plate, l.r.:
 Copyright secured by Ernest Knaufft,/1882; signed in
 margin in pencil, l.r.: Wm M Chase.
 Dunnigan Collection, 1976.1.228

4. **Gabrielle de Veaux Clements** (American, 1858–1948)
 A Quiet Corner, ca. 1884
 Etching, plate: 4 ¹¹⁄₁₆ × 8, sheet: 8 ¹³⁄₁₆ × 12 ⅞
 Signed in plate, l.l.: G.D. Clements./1.; inscribed in
 margin in pencil, l.r.: Voigt; on mat in pencil, l.r.:
 Selected for myself/Henry E. F. Voigt
 Dunnigan Collection, 1976.1.238

5. **Samuel Colman** (American, 1832–1920)
 Durham, England, ca. 1880
 Etching, plate: 4 ⅞ × 7 ⅞. sheet: 9 ⁵⁄₁₆ × 12 ¼
 Signed in plate with monogram, l.l.: .SC.
 Dunnigan Collection, 1976.1.265

6. **Reginald Cleveland Coxe** (American, 1855–1926)
 Untitled (Ships in Fog), 1886
 Etching, plate: 15 ½ × 22 ¼. sheet: 21 ⅜ × 31 ½
 Signed in plate, l.l.: R. Cleveland Coxe/—1886—;
 inscribed in plate, l.l.: Copyrighted—1886
 Dunnigan Collection, 1976.1.183

7. **Henry Farrer** (American, born England, 1844–1903)
 Sunset Coast of Maine, 1878
 Etching, plate: 3 ¹¹⁄₁₆ × 6 ⁵⁄₁₆; sheet: 4 ¾ × 7
 Signed in plate, l.l.: H. Farrer 1878; on mat in pencil, l.r.:
 H. Farrer Coast of Maine; inscribed on mat in pencil,
 l.c.: For my Collection/Henry E. F. Voigt
 Dunnigan Collection, 1976.1.495

8. **Henry Farrer** (American, born England, 1844–1903)
 The Day is Ending, Night Descending, 1886
 Etching, plate: 19 ½ × 32 ⅜; sheet: 27 ¼ × 40 ¾
 Signed in plate, l.l.: H. Farrer 1886.; inscribed in plate,
 u.l.: Copyrighted 1886, by Fishel, Adler & Schwartz,
 New York.; signed in margin in pencil, l.r.: Henry Farrer
 Dunnigan Collection, 1976.1.152

9. **Henry Farrer** (American, born England, 1844–1903)
 Moonrise, ca. 1889
 Etching, plate: 11 ¾ × 17 ⅞. sheet: 17 ⅜ × 23 ¼
 Signed in plate, l.l.: H Farrer; inscribed in margin in
 pencil, l.r.: V
 Dunnigan Collection, 1976.1.149

10. **Harry Fenn** (American, born England, 1845–1911)
 Lobster Cove, ca. 1889
 Etching, plate: 5 ¼ × 10 ¹¹⁄₁₆, sheet: 10 ¼ × 15 ¹⁄₁₆
 Signed in plate, l.l.: Harry Fenn.
 Dunnigan Collection, 1976.1.372

11. **Stephen James Ferris** (American, 1835–1915)
 Nydia (after George Fuller), 1883
 Etching, plate: 24 ⅜ × 16 ⅞, sheet: 29 × 22
 Signed in plate, l.l.: S.J. Ferris Etch 1883; l.r.: G Fuller
 Pinxt 1882; inscribed in plate, u.l.: Copyrighted 1884 by
 C Klackner, 17 E. 17th St. N.Y.; l.r.: Nydia.
 Dunnigan Collection, 1976.1.360

12. **R. Swain Gifford** (American, 1840–1905)
 Coal Pockets at New Bedford, 1879
 Etching, plate: 8 ⁷⁄₁₆ × 5 ⅞. sheet: 11 ⅜ × 9
 Signed in plate, l.r.: R Swain Gifford/—79
 Dunnigan Collection, 1976.1.83

13. **R. Swain Gifford** (American, 1840–1905)
 The Mouth of the Apponigansett, 1883
 Etching, plate: 7 ¾ × 11 ⅛, sheet: 14 ¼ × 19 ¾
 Signed in plate, l.l.: R. Swain Gifford 1883; inscribed in
 margin in pencil, l.r.: Selected for myself/Henry E. F.
 Voigt; on mat in pencil, l.l.: The Mouth of the
 Apponigansett
 Dunnigan Collection, 1976.1.84

14. **R. Swain Gifford** (American, 1840–1905)
 Untitled (Interior, Man Cleaning Gun by Fireplace), 1885
 Etching, plate: 4 ⅜ × 6 ⅝, sheet: 7 ¹⁵⁄₁₆ × 10 ¹⁵⁄₁₆
 Signed in plate, l.r.: R Swain Gifford; inscribed in plate,
 l.l.: 1885
 Dunnigan Collection, 1976.1.82

15. **Clement R. Grant** (American, 1849–1893)
 Watching and Waiting, ca. 1888
 Etching, plate: 10 × 5, sheet: 15 ¾ × 10 ⅜
 Signed in margin in pencil, l.l.: C R Grant; inscribed
 in plate, u.l.: Copyright 1888, by C. Klackner, 5 E. 17th
 St. N.Y.
 Gift of Ronald G. Pisano, Baker/Pisano Collection,
 1980.26

16. **Clement R. Grant** (American, 1849–1893)
 Untitled (Girl in Field, Waving Handkerchief), ca. 1889
 Etching, plate: 16 ⅝ × 10 ¼, sheet: 18 × 11 ⅜
 Signed in plate, l.r.: C R GRANT; in margin in pencil, l.l.:
 C R Grant; inscribed in plate, u.l.: Copyright 1889, by C.
 Klackner, 5 E. 17th St. N.Y.
 Gift of Lewis Adler, 1976.3.7

17. **Thomas Hovenden**
 (American, born Ireland, 1840–1895)
 The Chimney Corner, ca. 1886
 Etching, plate: 24 ⅞ × 19 ¹⁵⁄₁₆, 37 ⅜ × 25 ⅝
 Signed in plate with superimposed initials, l.r.:
 THovenden/Painter & Etcher; inscribed in plate, u.l.:
 Copyright, 1886, by C. Klackner 17 E. 17th St. N.Y.; l.r.:
 The Chimney Corner.
 Dunnigan Collection, 1976.1.122

18. **Thomas Hovenden**
 (American, born Ireland, 1840–1895)
 Untitled (Man Shaving), 1886
 Etching, plate: 23 × 16 ⅞, sheet: 29 ⅛ × 22
 Signed in plate, l.r.: THovenden/1886; signed in margin
 in pencil, l.r. Thos. Hovenden; inscribed in plate, l.c.:
 copyright 1887 , by Thos Hovenden.
 Dunnigan Collection, 1976.1.121

19. **Gertrude Rummel Hurlbut**
 (American, active 1880s–1909)
 Near East Hampton, L.I., 1880
 Etching, plate: 9 ¾ × 6 ¾; sheet: 13 ½ × 9 ½
 Signed in plate, l.r.: G.R.H./1880; inscribed in margin in
 pencil, l.r.: For my Collection/Henry E. F. Voigt; on mat
 in pencil, l.r.: G. R. Hurlbut
 Dunnigan Collection, 1976.1.328

20. **Hugh Bolton Jones** (American, 1848–1927)
 Untitled (Lake Scene with Lily Pads), ca. 1889
 Etching, plate: 15 ½ × 23 ⁹⁄₁₆, sheet: 21 ⁵⁄₁₆ × 27 ⁷⁄₁₆
 Inscribed in plate, u.l.: Copyright 1889, by H. Bolten
 Jones and Published by the Society of
 American Etchers
 Dunnigan Collection, 1976.1.349

21. **James S. King** (American, 1852–1925)
 Electric Power, Niagara Falls, ca. 1896–1900
 Etching, plate: 15 ¼ × 10 ⅞. sheet: 17 ⅞ × 13 ⅝
 Signed in margin in pencil, l.r.: Jas. S. King
 Dunnigan Collection, 1976.1.361

22. **Hendrik-Dirk Kruseman van Elten**
 (Dutch, 1829–1904, to United States 1865)
 On the Shepang River, Conn., 1880
 Etching, plate: 4 ¹⁵⁄₁₆ × 8 ⅞, sheet: 5 ¼ × 8 ⅞
 Signed in plate, l.l.: K van Elten. 1880.; inscribed in
 margin in pencil, l.r.: American Art Review/for my
 Collection/Henry E. F. Voigt
 Dunnigan Collection, 1976.1.176

23. **Hendrik-Dirk Kruseman van Elten**
 (Dutch, 1829–1904, to United States 1865)
 In the Grove, ca. 1882
 Etching, plate: 12 ⅛ × 18 ⅜. sheet: 13 ¹⁵⁄₁₆ × 19 ¾
 Signed in plate, l.l.: K. van Elten.; signed in margin
 in pencil, l.r.: Kruseman van Elten.; l.l.: To Mr. H. E. F.
 Voigt with kind regards of the artist.
 Dunnigan Collection, 1976.1.178

24. **Benjamin Lander** (American, 1842–1907)
When We Were Boys, ca. 1885
Etching, plate: 15 ½ × 21 ⅜, sheet: 18 × 24 ³⁄₁₆
Signed in plate, l.l.: —BENJ—LANDER—; inscribed
in plate, u.l.: Published by H. Wunderlich & Co. 868
Broadway, N.Y.
Dunnigan Collection, 1976.1.168

25. **Benjamin Lander** (American, 1842–1907)
On the Bay, ca. 1886
Etching, plate: 18 ½ × 25 ¼, sheet 22 ⅛ × 29 ³⁄₁₆
Signed in plate, l.l.: .BENJ. LANDER; signed in margin
in pencil, l.r.: Henry E. F. Voigt. with the compliments
of the Etcher/Benj Lander.; inscribed in plate, u.l.:
Copyright 1886, by Benj. Lander.
Dunnigan Collection, 1976.1.167

26. **Benjamin Lander** (American, 1842–1907)
Under the Willows, 1887
Etching, plate: 15 ⅞ × 21 ¾, sheet: 19 ¼ × 25 ⅛
Signed in plate, l.l.: —BENJ. LANDER—; signed in
margin in pencil, l.r.: Henry E. F. Voigt. with the
Compliments of the Etcher./Benj Lander; inscribed in
plate, u.l.: Copyright 1885 by Benj. Lander.
Dunnigan Collection, 1976.1.166

27. **William Henry Lippincott** (American, 1849–1920)
Stolen Moments, 1888
Etching, plate: 23 ¹³⁄₁₆ × 16 ½, sheet: 37 ⅜ × 25 ⅝
Signed in plate, l.l.: Wm.H:LIPPINCOTT 1888; inscribed
in plate, u.r.: Copyrighted by Radtke, Lauckner & Co.
New York, 1888.; in margin in pencil, l.r.: Voigt
Dunnigan Collection, 1976.1.313

28. **S. C. McCutcheon** (American, active 1880s)
Old Friends, 1881
Etching, plate: 5 ⅞ × 8 ¹⁵⁄₁₆, sheet: 7 ¹⁵⁄₁₆ × 11 ¹⁄₁₆
Signed in plate, l.r.: S C McCutcheon/ 9/1/81; inscribed
on mat in pencil, l.r.: For my Collection/Henry E. F. Voigt
Dunnigan Collection, 1976.1.323

29. **Charles F. W. Mielatz**
(American, born Germany, 1864–1919)
Trinity Church Steeple During a Conflagration, 1885
Etching, plate: 7 ⅞ × 4, sheet: 13 ¼ × 8 ⅜
Signed in plate, l.l.: MIELATZ/85
Dunnigan Collection, 1976.1.213

30. **Charles F. W. Mielatz**
(American, born Germany, 1864–1919)
Narragansett Mill Pond, 1886
Etching, plate: 22 ⅜ × 13 ⅜, sheet: 25 ½ × 18 ⅜
Signed in plate, l.l.: MIELATZ. '86.; in margin in pencil,
l.r.: To my friend Mr Voigt/with my compliments/Chas
F. W. Mielatz; inscribed in plate, u.l.: Copyright 1886, by
Fishel, Adler & Schwartz.
Dunnigan Collection, 1976.1.215

31. **John Austin Sands Monks** (American, 1850–1917)
Twilight, 1883
Etching, plate: 8 ⁵⁄₁₆ × 11 ⅜, sheet: 12 ⅜ × 17 ⅜
Signed in plate, l.r.: J A S Monks —83—; inscribed in
margin in pencil, l.r.: Selected for myself/V/Henry E.F.
Voigt; on mat in pencil, l.l.: Twilight
Dunnigan Collection, 1976.1.193

32. **John Austin Sands Monks** (American, 1850–1917)
The Patriarch, ca. 1885
Etching, plate: 16 × 14, sheet: 18 ⅜ × 16 ¼
Signed in margin in pencil, l.l.: J.A.S. Monks/To his
friend/Henry E. F. Voigt; inscribed on mat in pencil, l.r.:
For my Collection/Henry E. F. Voigt
Dunnigan Collection, 1976.1.195

33. **Mary Nimmo Moran**
(American, born Scotland, 1842–1899)
Solitude, 1880
Etching, plate: 5 ⅜ × 7 ½, sheet: 8 × 11
Signed in plate, l.r.: M.N.M/1880
Dunnigan Collection, 1976.1.50

34. **Mary Nimmo Moran**
(American, born Scotland, 1842–1899)
Evening— Easthampton, 1881
Etching, plate: 7 ⅞ × 4 ½, sheet: 11 ⅝ × 7 ⅝
Signed in plate, l.l.: M. NIMMO MORAN/1881; in
margin in pencil, l.l.: M. Nimmo Moran
Gift of Mrs. Robert Malcolm Littlejohn, 1956.47.6

35. **Mary Nimmo Moran**
(American, born Scotland, 1842–1899)
The Goose Pond—Easthampton, 1881
Etching, plate: 7 ⅛ × 9, sheet: 8 ½ × 10 ⅛
Signed in margin in pencil, l.l.: M Nimmo Moran.
Dunnigan Collection, 1976.1.57

36. **Mary Nimmo Moran**
(American, born Scotland, 1842–1899)
"'Tween the Gloaming and the Mirk," 1883
Etching and mezzotint, plate: 7 ½ × 11 ¼, sheet: 15 × 19 ¾
Signed in plate, l.l.: M. NIMMO MORAN/1883; inscribed
in margin in pencil, l.r.: Selected for myself/Henry E. F.
Voigt; on mount in pencil, l.l.: "Tween the Gloamin and
the Mirk/When the Kye come hame."
Dunnigan Collection, 1976.1.54

37. **Mary Nimmo Moran**
(American, born Scotland, 1842–1899)
Georgica Pond—Looking Seaward, 1885
Etching, plate: 11 ½ × 17 ⅜, sheet: 22 × 28 ³⁄₁₆
Signed in plate, l.r.: M N Moran/1885
Gift of Lewis Adler, 1976.3.5

38. **Mary Nimmo Moran**
(American, born Scotland, 1842–1899)
Home Sweet Home, 1885
Etching, plate: 15 ¾ × 13, sheet: 29 ⅛ × 22
Signed in plate, l.r.: M. N. MORAN. 1885; inscribed
in plate, u.l.: The "Home Sweet Home."/of John
Howard Payne./Easthampton.; inscribed in plate, l.r.:
Copyright 1886 by C. Klackner, 17 E. 17th St. N. Y.
Dunnigan Collection, 1976.1.55

39. **Mary Nimmo Moran**
(American, born Scotland, 1842–1899)
*"Where Through the Willows Creaking Loud, is Heard the
Busy Mill,"* 1886
Etching, plate: 24 ¾ × 32 ⅜, sheet: 25 ⁹⁄₁₆ × 37 ⅜
Signed in plate, l.l.: M Nimmo Moran/1886; inscribed
in plate, u.l.: Copyrighted 1886, by Fishel, Adler &
Schwartz, New York
Dunnigan Collection, 1976.1.56

40. **Peter Moran** (American, born England, 1841–1914)
On the Road to Santa Fe, ca. 1885
Etching, plate: 4 ⅞ × 6 ¾ , sheet: 11 ¼ × 15 ¼
Signed in plate, l.l.: PMoran; inscribed in margin in
pencil, l.l.: Hist Etch.: l.r.: For my Collection/Henry E.
F. Voigt
Dunnigan Collection, 1976.1.62

41. **Peter Moran** (American, born England, 1841–1914)
Untitled (Cows in Field), ca. 1886
Etching, plate: 16 ⅛ × 22 ⅝, sheet: 19 ⅛ × 24 ⅞
Signed in plate, l.l.: P.Moran; inscribed in plate, u.l.:
Copyright 1886. by C.Klackner, 17 E. 17th St. N.Y.; in
margin in pencil, l.r.: V
Dunnigan Collection, 1976.1.63

42. **Peter Moran** (American, born England, 1841–1914)
Untitled (Man Plowing Field), ca. 1886
Etching, plate: 17 × 22, sheet: 22 × 29
Signed in plate, l.c.: P.Moran; inscribed in plate, u.l.:
Copyright 1886, by C. Klackner, 17 E. 17th St. N.Y.
Dunnigan Collection, 1976.1.68

43. **Peter Moran** (American, born England, 1841–1914)
The Ploughman, ca. 1887
Etching, plate: 18 ⅛ × 33 ¾, sheet: 25 ⁹⁄₁₆ × 37 ¼
Inscribed in plate, u.l.: Copyrighted by Radtke,
Lauckner & Co., New York 1888
Dunnigan Collection, 1976.1.70

44. **Thomas Moran** (American, born England, 1837–1926)
The Rainbow, 1880
Etching: plate: 3 ¾ × 7 ¹¹⁄₁₆, sheet: 7 ⅝ × 11 ⅛
Signed in plate with monogram, l.l.: TM; inscribed in
plate in reverse, l.r.: Three Mile Harbor; in margin in
pencil, l.l.: [erased] For my Collection/Henry E. F. Voigt;
l.r.: Th. Moran
Dunnigan Collection, 1976.1.37

45. **Thomas Moran** (American, born England, 1837–1926)
Tower Falls, 1880
Etching, plate: 5 ⅞ × 3 ½, sheet: 10 ¾ × 7 ⅜
Signed in plate with monogram, l.l.: TM; inscribed on
mount in pencil, l.r.: For my Collection/Henry E. F. Voigt
Dunnigan Collection, 1976.1.42

46. **Thomas Moran** (American, born England, 1837–1926)
A Tower of Cortez—Mexico, 1883
Etching, plate: 11 ⅜ × 9 ½, sheet: 19 ¼ × 14
Signed in plate with superimposed initials, l.r.:
TMoran/1883; inscribed in plate in reverse, l.l.: A Tower
of Cortes [sic]/Mexico; in margin in pencil, overlapping
mount, l.r.: Selected for myself/Henry E. F. Voigt; on
mount in pencil, l.l.: A Tower of Cortes [sic]
Dunnigan Collection, 1976.1.46

47. **Thomas Moran** (American, born England, 1837–1926)
The Much Resounding Sea, 1886
Etching, plate: 16 ½ × 34 ⅜, sheet: 25 ⅜ × 37 ⅜
Signed in plate with monogram, l.l.: TM/1886;
inscribed in plate, u.l.: Copyright 1886, by C. Klackner,
17 E. 17th St. N.Y.
Dunnigan Collection, 1976.1.32

48. **Thomas Moran** (American, born England, 1837–1926)
Morning, 1886
Etching, plate: 11 1⁄16 × 17 ⅛, sheet: 16 11⁄16 × 22 3⁄16
Signed in plate with monogram initials, l.r.:
TMoran/1886; in margin in pencil, l.l.: T.Moran
Littlejohn Collection, 1961.3.162

49. **Thomas Moran** (American, born England, 1837–1926)
A Wreck—Montauk, 1886–1888
Etching with mezzotint, plate: 5 13⁄16 × 7 ⅞,
sheet: 9 ⅛ × 11 ⅜
Signed in plate with superimposed initials, l.r.: TMoran
Littlejohn Collection, 1961.3.167

50. **Thomas Moran** (American, born England, 1837–1926)
The Gate of Venice, 1888
Etching, plate: 21 ½ × 34 ¾:
Sheet: 25 ⅜ × 37 ½
Signed in plate with superimposed initials, l.l.: TMoran
1888, in margin in pencil, l.r.: T.Moran.; inscribed in
plate, u.l.: Copyright 1888, by C. Klackner, 5 E. 17th St. N.Y.
Dunnigan Collection, 1976.1.47

51. **Thomas Moran** (American, born England, 1837–1926)
Untitled (Fishing boat on storm-tossed sea; after Harry
Chase), 1890
Etching: plate: 27 × 19 ¾, sheet: 37 ⅜ × 25 ⅝
Signed in plate with superimposed initials, l.r.: TMoran
1890; inscribed in plate, u.l.: Copyrighted by Radtke,
Lauckner & Co., New York, 1890; signed in plate, l.l.: H
Chase
Dunnigan Collection, 1976.1.48

52. **James Craig Nicoll** (American, 1846–1918)
In the Harbor, 1880
Etching, plate: 12 ½ × 9 ½, sheet: 18 3⁄16 × 13 5⁄16
Signed in plate, l.l.: J. C. Nicoll./82.
Dunnigan Collection, 1976.1.72

53. **James Craig Nicoll** (American, 1846–1918)
A Winter Morning, ca. 1887
Etching, plate: 18 15⁄16 × 23 15⁄16, sheet: 22 × 29
Signed in plate, l.l.: J. C. Nicoll NA.: in margin in pencil,
l.r.: To my friend Mr. Henry E.F. Voigt/J. C. Nicoll.;
inscribed in plate, u.l.: Copyright 1887, by Fishel, Adler &
Schwartz, New York.
Dunnigan Collection, 1976.1.75

54. **Stephen Parrish** (American, 1846–1938)
Rocks of Cape Ann, 1881
Etching, plate: 6 13⁄16 × 14 ⅜,
sheet: 9 ⅜ × 16 ⅞
Signed in plate, l.l.: S. Parrish; inscribed in plate, l.r.: 45/
Rocks of Cape Ann
Dunnigan Collection, 1976.1.10

55. **Stephen Parrish** (American, 1846–1938)
Low Tide—Bay of Fundy, 1882
Etching, plate: 11 13⁄16 × 18 ¾, sheet: 18 7⁄16 × 25 ½
Signed in plate, l.l.: S. Parrish; inscribed in plate, l.r.:
Low tide — Bay of Fundy 64
Dunnigan Collection, 1976.1.30

56. **Stephen Parrish** (American, 1846–1938)
An Old Acadian Inn Yard, 1882
Etching, plate: 9 × 13, sheet: 14 × 17 ¾
Signed in plate, l.l.: Stephen Parrish; inscribed in plate,
l.r.: 71
Dunnigan Collection, 1976.1.29

57. **Stephen Parrish** (American, 1846–1938)
A Gale at Fécamp (Normandie), August 1886
Etching, plate: 13 ¾ × 15 ½, sheet: 18 × 23 ⅛
Signed in plate, l.l.: stephen Parrish/Fécamp; in
margin in pencil, l.r.: To Mr. Henry E. F. Voigt with
compliments of/.Stephen Parrish
Dunnigan Collection, 1976.1.11

58. **Stephen Parrish** (American, 1846–1938)
A Gloucester Wharf, 1886
Drypoint, plate: 17 ⅜ × 11 ⅜, sheet: 23 3⁄16 × 18 ⅛
Signed in plate, l.c.: stephen Parrish; u.l.: SP; in margin
in pencil, l.r.: To Mr. Henry E. F. Voigt./with kind regards
of/.Stephen Parrish.; inscribed in margin in pencil, l.r.
corner: V.
Dunnigan Collection, 1976.1.9

59. **Stephen Parrish** (American, 1846–1938)
A Squall—Bay of Fundy, 1888
Etching, plate: 15 ¾ × 23 ¾, sheet: 21 ¾ × 28 ⅜
Signed in plate, l.l.: stephen Parrish; inscribed in plate,
l.c.: Published "88, by J. D. Waring, N.Y. Copyrighted by
Stephen Parrish, "88
Dunnigan Collection, 1976.1.28

60. **Charles Adams Platt** (American, 1861–1933)
Provincial Fishing Village, 1882
Etching, plate: 13 ⅜ × 24 9⁄16, sheet: 22 × 30 13⁄16
Signed in plate, l.r.: C. A. Platt; inscribed in plate, l.l.:
1882; u.r.: 40
Dunnigan Collection, 1976.1.397

61. **Charles Adams Platt** (American, 1861–1933)
Low Tide, Honfleur, 1887
Etching, plate: 4 ⅜ × 6 ¼, sheet: 9 ½ × 12 1⁄16
Signed in plate, l.r.: C A Platt—1887
Dunnigan Collection, 1976.1.309

62. **Henry M. Rosenberg** (American, 1858–1947)
Untitled, 1889
Etching, plate: 6 ⅞ × 20 ⅞, sheet: 10 ⅞ × 27 ½
Signed in plate with intertwined initials, l.r.:
HMRosenberg/89 /Dec. 7: inscribed in plate, u.r.:
Copyright 1889, Jellinek & Jacobson, N. Y.: in margin in
pencil, l.r.: Voigt
Dunnigan Collection, 1976.1.332

63. **George Henry Smillie** (American, 1840–1921)
Untitled (Man and Woman Reclining on River Bank), 1881
Etching, plate: 4 7⁄16 × 6 15⁄16, Sheet: 5 ⅜ × 8
Signed in plate, l.r.: Geo. H. Smillie—/1881—
Dunnigan Collection, 1976.1.139

64. **George Henry Smillie** (American, 1840–1921)
Old New England Orchard, 1883
Etching, plate: 8 1⁄16 × 12, sheet: 14 ¼ × 19 ¼
Signed in plate, l.l.: Geo. H. Smillie—1883; inscribed in
margin in pencil, l.r.: Selected for myself/Henry E. F.
Voigt; l.l.: Old New England Orchard
Dunnigan Collection, 1976.1.140

65. **James David Smillie** (American, 1833–1909)
The Way to the River, 1880
Etching, plate: 7 5⁄16 × 5 13⁄16, sheet: 10 ⅜ × 8 ¾
Signed in plate with monogram initials, l.l.: The way to
the/River./JDSmillie/no 16. June, 1880.
Dunnigan Collection, 1976.1.135

66. **James David Smillie** (American 1833–1909)
Rough Sport in the Yosemite, 1886
Etching, plate: 9 ½ × 15 ⅜, sheet: 13 ⅜ × 18 15⁄16
Signed in plate with monogram initials, L.l.: JDSmillie.
Jan. 7 '86./Op.36.; inscribed in margin in pencil, l.r.:
To H. E. F. Voigt with best wishes of/James D. Smillie;
inscribed on mat in pencil, l.r.: For my Collection/
Henry E. F. Voigt
Dunnigan Collection, 1976.1.137

PHOTOGRAPHY CREDITS

67. **Charles Walter Stetson**
(American, 1858–1911)
Gamin (after Thomas Couture), 1884
Etching, plate: 20 ½ × 19 ⅞, sheet: 27 ⅜ × 21 ½
Signed in plate, l.r.: Charles Walt: Stetson; inscribed in
plate, l.l.: From the picture by T. COUTURE; monogram,
l.c.: 18CWS84
Dunnigan Collection, 1976.1.187

68. **John Henry Twachtman**
(American, 1853–1902)
Autumn, Avondale, ca. 1879
Etching, plate: 5 ½ × 7 ⅜, sheet: 7 × 10 ⅜
Signed on image in pencil, l.l.: Twachtman; stamped in
lower right corner of image in red: OttO
Littlejohn Collection, 1961.3.20

69. **Augustus D. Van Cleef**
(American, 1851–1918)
The Tomb of a Modern Leander, Fisher's Island, 1882
Etching, plate: 4 ½ × 8 ⅞, sheet: 8 ¹¹⁄₁₆ × 12 ⅞
Signed in plate, l.r.: A van Cleef 82; inscribed in
margin in pencil, l.r.: For my Collection/Henry
E. F. Voigt/Van Cleef
Dunnigan Collection, 1976.1.327

70. **Charles A. Vanderhoof** (American, born 1918)
Sand Dunes, Virginia, ca. 1892
Drypoint, plate: 5 ¹⁵⁄₁₆ × 8 ¹⁵⁄₁₆, sheet 9 × 12 ⁷⁄₁₆
Dunnigan Collection, 1976.1.318

71. **Thomas Waterman Wood** (American, 1823–1903)
Fresh Eggs, 1882
Etching, plate: 15 ½ × 11, sheet: 19 ¹¹⁄₁₆ × 14 ¾
Signed in plate, l.l.: Fresh Eggs./Copyright by/
T.W.Wood./1882'.; in margin in pencil, l.c.: To Mr Henry
E. F. Voigt/with the compliments of/T. W. Wood—
Dunnigan Collection, 1976.1.96

72. **Thomas Waterman Wood** (American, 1823–1903)
The Man of War, 1886
Etching, plate: 12 ⅝ × 7 ½, sheet: 19 ½ × 12 ½
Signed in plate, l.l.: T. W. WOOD./Copyright/1886.; in
margin in pencil, l.c.: To Mr. Henry E. F. Voigt from T.
W. Wood.; inscribed in plate, u.l.: The Man of War.; l.c.:
Collection of Miss Catharine L. Wolfe.; in margin in
pencil, l.r.: for my Collection/Henry E. F. Voigt
Dunnigan Collection, 1976.1.101

73. **Thomas Waterman Wood** (American, 1823–1903)
The Man of Peace, 1886
Etching, plate: 12 ⅝ × 7 ⅝, sheet: 19 ⅜ × 12 ⁷⁄₁₆
Signed in plate, l.l.: T. W. WOOD./Copyright./1886.; in
margin in pencil, l.c.: To Mr. Henry E. F. Voigt from T.
W. Wood.; inscribed in plate, u.l.: The Man of Peace.;
l.c.: Collection of Miss Catharine L. Wolfe.; in margin in
pencil, l.l.: for my Collection/Henry E. F. Voigt
Dunnigan Collection, 1976.1.100

All photographs are by Gary Mamay
with the exception of Figure 1, Courtesy Arader Gallery, Philadelphia

INDEX

Page numbers in *italics* indicate illustrations.